IMAGES
of America

SANDY HOOK

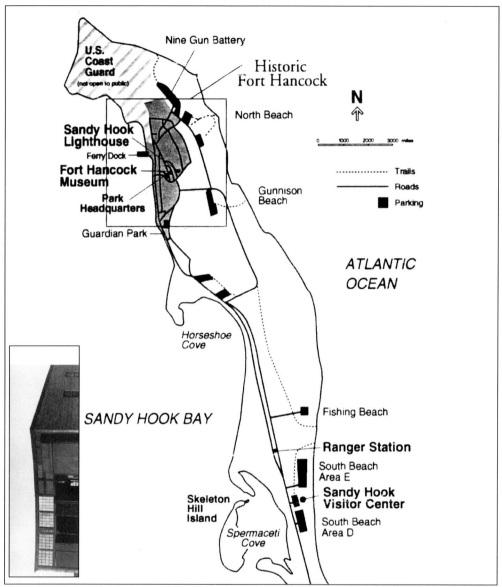

Sandy Hook is a 1,665-acre barrier beach on the northern tip of the New Jersey shore. This map from a contemporary National Park Service brochure provides a helpful guide to much of the content of this book. Arriving by automobile, one passes the Fee Plaza at the southern end; many stop at the Sandy Hook Visitor Center, a former life saving station (see p. 15), for orientation. Several pictures of the Coast Guard area at the north end are included, but the grounds are not open to the public. Most places of historic and educational interest are located in the historic area, which is enclosed by the square on this map and outlined on a map on p. 24. Horseshoe Cove was once the site of an important dock (p. 9) and a coastal defense battery (p. 96), and is now a major bird-watching area. South Beach is the popular bathing area, but the less-accessible Gunnison Beach has its adherents who are fond of its "clothing optional" status (p. 125). The inset, a c. 1780 work by British Revolutionary War map maker John Hills, is not perfectly scaled but demonstrates the proximity of the lighthouse to the northern tip, showing that the peninsula was once an island.

IMAGES
of America

SANDY HOOK

Randall Gabrielan

ARCADIA
PUBLISHING

Published by Arcadia Publishing
Charleston, South Carolina

Printed in the United States of America

Library of Congress Catalog Card Number: 2007962057

For all general information contact Arcadia Publishing at:
Telephone 843-853-2070
Fax 843-853-0044
E-mail sales@arcadiapublishing.com
For customer service and orders:
Toll-Free 1-888-313-2665

Visit us on the Internet at www.arcadiapublishing.com

Cover Photograph: See p. 98.

This book is dedicated to Tova Navarra, an artist, photographer, historian, critic, and prolific writer. She is the author of many books and has had a successful journalism career that includes her own syndicated column. A veritable renaissance woman of New Jersey arts and letters, Tova is also a nurse—a calling that reflects her qualities as a compassionate, generous, and spiritual human being. I am pleased and proud to have her as a friend and colleague.

CONTENTS

ACKNOWLEDGMENTS

The enthusiasm and support of the staff at the Sandy Hook Unit of the Gateway National Recreational Area and generous access to their collections were of paramount importance to the completion of this book. Historian Thomas Hoffman has developed an encyclopedic knowledge of the park and its history in over two decades of service. This book, as written, would not have been possible without his sharing that knowledge. Curator Cary Wiesner has a thorough mastery of Sandy Hook's collections. He guided the author through it with enthusiasm good cheer and detailed knowledge. Unit Superintendent Charles "Chuck" Baerlin and Chief of Interpretation Louis J. Venuto provided their executive backing. My heartfelt thanks goes to each of them.

John Rhody's postcard collection has enhanced nearly all of the author's works. His Sandy Hook material is of special significance. Robert Schoeffling's support, as with many of my books, began prior to the project. With *Sandy Hook*, his redoubled effort as the book was nearing completion uncovered some of the most important images. Thanks, John and Bob.

My deepest thanks to all the picture lenders, including Wesley V. Banse, Olga Boeckel, Christine Matthews Burger, Roberta Chase, Bertha Hickey Conover, Wesley Crozier, the Eastern National Park & Monument Association (for permission to use two copyrighted postcards), Robert Stanley Osborn, Photography Unlimited by Dorn's, Karen L. Schnitzspahn, Michael Steinhorn, Peter Van Nortwick, Keith Wells, Richard C. Winters, and Al Zwiazek (for permission to use a copyrighted postcard).

I thank Robert D. Zink, one of the nation's foremost coastal defense experts, for advice on that topic.

I acknowledge George H. Moss Jr., although not a direct contributor to this book, for founding the collection at Gateway, Sandy Hook, which was accessed liberally (see p. 121).

I thank Harold Solomon, last but not least, not as a cliché, but because his photographic postcard contributions made after the project "closed" made a significant improvement in the book.

INTRODUCTION

Sandy Hook, a 1,665-acre barrier beach peninsula in Monmouth County, located on the northern tip of its Atlantic Ocean coast, is many things to its legions of visitors. Its miles of bathing beaches make it the area's foremost recreational site. Its natural environment is rich with ancient plantings, including beach cactus and a famed holly forest. The appeal of its environment pre-dates European settlement. The Native Americans who occupied the area sold the land to white settlers, but, unaware of European legalisms, they insisted after transferring title that the sale did not include surrender of access rights for gathering beach plums. Their successful effort to obtain additional compensation is part of Sandy Hook lore.

Birders flock here for Sandy Hook's appeal to migrating birds. At least one—the piping plover—is given a beach-front nesting area that is off limits to humans. The U.S. Coast Guard maintains a base at the northern tip, and several scientific and educational organizations also call Sandy Hook home. Most are housed in the buildings that gave the area its historic appeal, including Fort Hancock and the Army Ordinance Department Proving Ground. This book touches on each subject but focuses on the fort and proving ground.

Fort Hancock was, for most of the first half of the 20th century, one of the most heavily armed fortifications in America. The waters around the hook are the entrance to the harbor at New York. By the mid-18th century, Sandy Hook's maritime significance was recognized following the 1764 completion of its lighthouse, which is America's oldest continually lit lighthouse. Sandy Hook's strategic importance was made manifest in the Revolutionary War, through its occupancy by forces loyal to the British Crown. Sandy Hook provided the British and their supporters with a safe local haven.

Early American fortifications date from around the War of 1812. Plans for a significant fort were made in the 1850s, and construction of a massive stone structure began in 1859. This structure—never completed, as it became obsolete soon after it was begun—was known as "the Fort at Sandy Hook," or informally as the "Civil War-era fort." Small parts of it were absorbed into later construction, including the Sandy Hook Proving Ground, begun in 1874. Its development, which is traced in Chapter Three, resulted in a facility that tested, through World War I, every gun that went into army service and a variety of ordnance and protective armor. The prominence of many large guns in Sandy Hook's past is well known. Less appreciated, however, is the distinction between the proving ground and the coastal defense fort. The popular images of long rows of guns lined up at Sandy Hook belong to the proving ground. Successfully tested weapons were sent into service at U.S. Army installations all over. The operation, always

compromised by the too-short firing range, was moved to the Aberdeen (Maryland) Proving Grounds in 1919.

Forts at important coastal cities or facilities were necessary for protection against enemy warships, the principal threat of sneak attack until World War II–era aviation. The channels into New York Harbor were narrow, and Fort Hancock was designed to enable its forces to sink any approaching enemy. It supplemented earlier fortifications in New York, including Fort Wadsworth, Staten Island, part of the Gateway National Recreation Area, and Fort Hamilton, Brooklyn, a separate facility open to the public.

Construction of Fort Hancock gun emplacements began in 1890, following government plans in the 1880s to reinforce many of the nation's coastal defenses. The fort was named for Gen. Winfield Scott Hancock in 1895 and, after years of supervision by its builders, the Army Engineers Department was placed in the operational control of the Coast Artillery Department on March 22, 1898.

The history of warfare is a long, ongoing effort to develop weapons that could overcome defenses. This process was evident at Fort Hancock through many changes, including the size of its guns, their protection, location, manner of fire, and type of ordnance and powder charge. Chapter Four traces some developments through specific examples. Some gun emplacements were made obsolete not long after their installation, such as the shorter-range mortars, which became ineffective against the longer-range guns of battleships.

Fort Hancock's cannons were obsolete by the end of World War II, as aerial bombardment provided new threats. Fort Hancock would see renewed importance early in the Cold War as an anti-aircraft missile site, but this role also became obsolete in the ballistic missile era. The fort was closed in 1974, ending Sandy Hook's military career.

Following World War II, the coastal defense facilities were disarmed and many unneeded buildings, some of which appear in Chapter Two, were demolished. Much has been left intact. The lighthouse and Officers Row are two of the best-known architectural icons of the New Jersey coast. Much of what remains, however, has deteriorated due to budgetary constraints. Part of one of New Jersey's most important historic sites is crumbling before our eyes.

The National Park Service is attempting to secure wider use of Sandy Hook and public participation in its preservation through the Historic Leasing program. Many buildings, including most of Officers Row, some barracks, and the lighthouse keeper's house, will be available for occupancy with a long-term lease to those whose plans for rehabilitation and preservation are acceptable components of their proffered consideration. The program is undertaking proposals as this book goes to press; for more information, contact the unit superintendent at (732) 872-5910.

Sandy Hook's history is being preserved through the Park Service's museum and curatorial operations. Its past is brought to life in the Sandy Hook Museum, exhibits at the visitors center, and public programs. Volunteers staff an exhibition example from Officers Row, Building 1, which is known as History House.

The Sandy Hook collection of over 15,000 items continues to grow. Shortly before completion of this book, the collection's importance to the staff and local researchers, including this author, received wide public airing during discussions about its storage plans. The pledges of funds for enhanced facilities should be an aid to the collection's continued expansion. Those with items to donate may call the park at (732) 872-5953.

Park Historian Tom Hoffman has accumulated a wide body of knowledge in over two decades service, often through individual contact with those stationed, residing, or employed at Sandy Hook. He would also like to hear from those with personal familiarity. His office number is (732) 872-5950.

The author finishes one book with the hope a second volume will be forthcoming. Much of the Sandy Hook story remains to be illustrated. His images are obtained via copying borrowed pictures and historical material. He may be contacted at the following address: 71 Fish Hawk Drive, Middletown, NJ, 07748, or by phone at (732) 671-2645.

One

MARITIME HISTORY

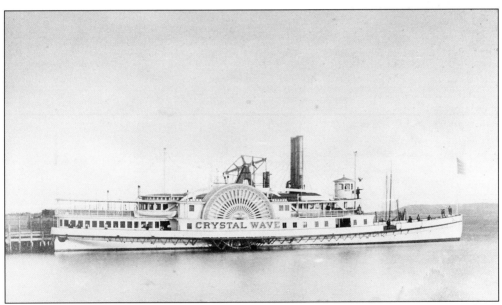

The opening of the Long Branch and Sea Shore Railroad in 1865 made Sandy Hook an important dockage for public transportation. The line obtained permission from the federal government and built its first dock at Spermaceti Cove, which was replaced by the dock in deeper waters to the north at Horseshoe Cove in 1870. A succession of mergers made the road part of the Central Railroad of New Jersey, which used the dock through the 1891 season. Government officials forced it to relocate, as a passenger railroad was not compatible with the proving ground operation. Pictures at either dock are rare. This view of the Crystal Wave is undated, but George J. Moss Jr.'s *Steamboat to the Shore* indicates the vessel docked at Sandy Hook in 1875, 1876, and 1878.

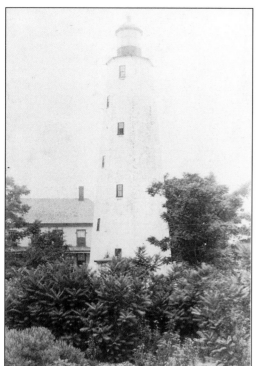

The lighthouse at Sandy Hook was built by New York City interests, notably merchants. They enlisted the support of the Assembly and citizens, who funded the project with two lotteries. The lighthouse, which then stood only 500 feet from the tip of the hook, was first lit on June 11, 1764. It guided ships around the shoals and sandbars that had claimed a great number of wrecked vessels. A third-order Fresnel lens was installed in 1857 and still remains. An 1863 renovation included the addition of a red-brick interior lining for reinforcement and the installation of a new, iron, spiral staircase. Whale oil and kerosene were early illuminants. Electricity was tried experimentally in 1896, but the light was not fully electrified until c. 1930. Land accretions now distance the lighthouse about a mile from the northern tip. This c. 1900 photograph shows an excess of wild vegetation.

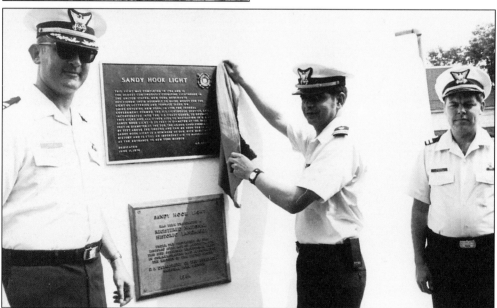

Sandy Hook Lighthouse is the nation's oldest continually lit lighthouse. One of the most recognizable icons of the Jersey shore, it was declared a National Historic Landmark on June 11, 1964. Its image has appeared on two U.S. postage stamps. The light, maintained by the Sandy Hook Coast Guard Station and kept on 24 hours a day, is visible for 19 miles on clear nights. The lighthouse was rededicated June 11, 1976. The honors were performed by the following Coast Guard officers, pictured here from left to right: Commander John H. Holmead, Lt. Commander John B. Schempf, and Lt. Robert Haneberg.

The money for a lighthouse keeper and other operational expenses was first raised by a tonnage tax of three pence per ton on ships sailing into New York Harbor. The keeper formerly resided in the building adjacent to the lighthouse. The keepers house, now standing opposite, was built in 1883. The house was occupied by a park employee in recent years, but it will be available to the public under the Historic Leasing program. E.G. Hand, pictured here c. 1936, was a longtime keeper, but no biographical information has been found. (Collection Gateway, Sandy Hook.)

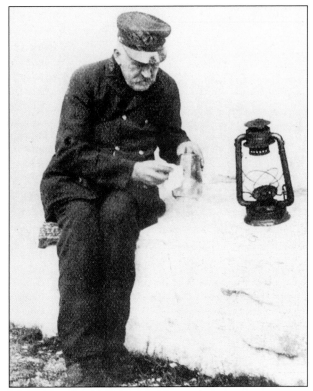

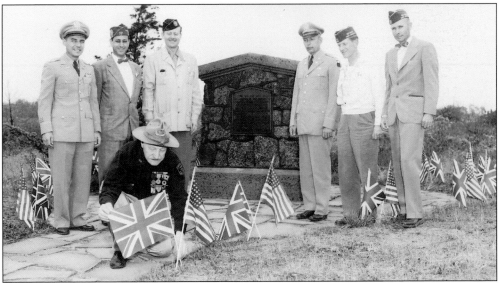

British Lt. Hamilton Douglas-Halyburton and 13 shipmates perished in a sudden storm on December 31, 1783. An early monument erected by his mother in the late 1780s was wrecked, tradition claims, by French sailors c. 1804. Skeletons, believed to be those of the lost men, were discovered in 1908. A replacement monument was erected in 1937 near Horseshoe Cove, east of the road. An annual memorial service (shown here) on May 30, 1956, was held for some years but has been discontinued. See George H. Moss Jr.'s *Another Look at Nauvoo to the Hook* for a full-chapter account on Halyburton. (The Dorn's Collection.)

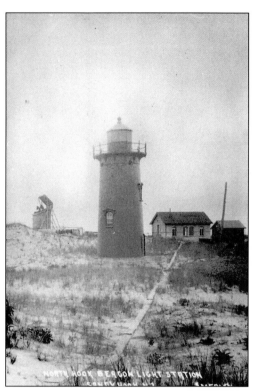

Due to the land accretions that had built up the northern tip, an additional light was needed to mark the spot. A North Beacon, seen in this *c.* 1910 postcard, was erected by 1880. It and the adjoining keeper's house were taken down in 1917, as they were deemed in the way of potential wartime gunfire. The lighthouse was re-erected in 1921, in the Hudson River at Jeffreys Hook. It was made obsolete by the 1931 construction of the George Washington Bridge, which had lights to guide river traffic. The lighthouse, however, achieved legendary stature as "the little red lighthouse" from a children's book. The structure is now owned by the City of New York as part of Fort Washington Park.

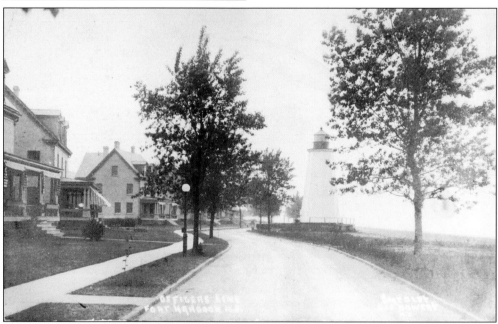

A West Beacon, erected by 1880, was a range light that, when properly aligned with the main light, marked the channel from Raritan Bay to the main channel around the hook. It was removed in the 1930s, perhaps early in the decade. House numbers 3 and 4 of Officers Row are also seen in this *c.* 1910 postcard, along with old-style light posts, which are of a type the Park Service would like to re-install. (Collection of John Rhody.)

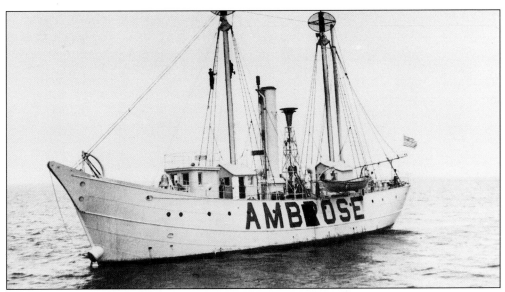

This undated postcard, perhaps *c.* 1915, appears to be Lightship Number 87, a 683-ton vessel built in Camden, New Jersey, in 1907; it measured 135 feet and 9 inches in length, with a beam of 29 feet and a draft of 12 feet. Each mast had a light; the main mast was used when the foremast was being refilled with oil. Lamps of 1,000 watts and 375-millimeter lenses were installed in the 1930s. This lightship served in the Ambrose Channel until it was replaced by a newer vessel in 1932. After service elsewhere, it was sent to the South Street Seaport Museum in New York in 1968. (Collection of John Rhody.)

Ambrose Channel is named for John Wolfe Ambrose (1838–1899), an engineer who helped develop New York's docks and channels and successfully lobbied Congress for funds for the deep-water channel named for him. It is now lit by an unmanned platform located at 40 degrees, 27 minutes, and 31 seconds north latitude and 73 degrees, 49 minutes, and 51 seconds west longitude. The prefabricated steel tower was built in three months in 1967 at a reported cost of $2.4 million. It initially had a crew of six, prior to becoming fully automated in 1988. The tower has two decks, with the upper one obviously a heliport, as evidenced by this August 23, 1967 picture. An HH-52 helicopter is seen on deck at the departure of the last Ambrose lightship. (Collection Gateway, Sandy Hook.)

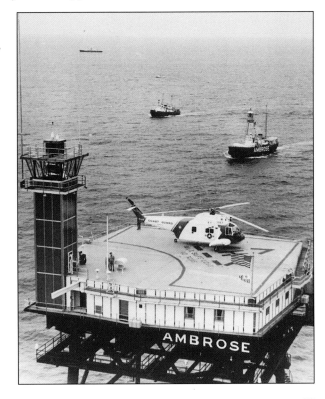

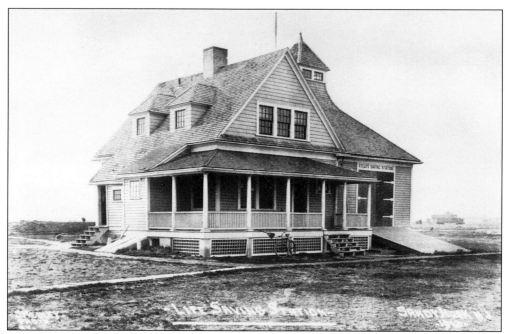

The federal maritime life saving service began in 1849, spurred by Congressman Dr. William A. Newell of Allentown, New Jersey. He had been interested in the subject since witnessing helplessly an 1839 shipwreck off Long Beach Island, where 13 crewmen drowned trying to swim 300 yards to shore in rough waters. Life Saving Station Number 1, one of several that lined the New Jersey shore 10 miles apart, was built at the north end of Sandy Hook in 1849. That building was replaced by this one in 1891.

The original site of Station Number 1 is the present location of the Post Chapel, now called the auditorium, Building 35. The station was moved closer to the tip of the hook c. 1915, as extensive construction of both Fort Hancock and proving ground structures blocked its view of the ocean. This building was demolished after World War II. (Collection of John Rhody.)

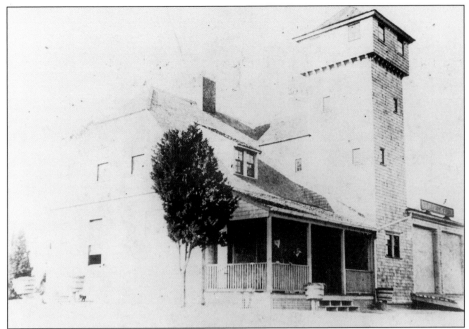

The third Spermaceti Cove Life Saving Station Number 2, built in 1894, is shown here c. late 1890s. At left is "Captain Jack" Edwards, the keeper from 1879 to 1899. The building was closed by the Coast Guard after World War II and was vacant until the Sea Scouts occupied it in the 1950s. Later occupancy by the former State Park and as a Brookdale Community College learning center preceded its opening in 1974 as the Sandy Hook Visitor Center, its present occupancy. (Collection Gateway, Sandy Hook.)

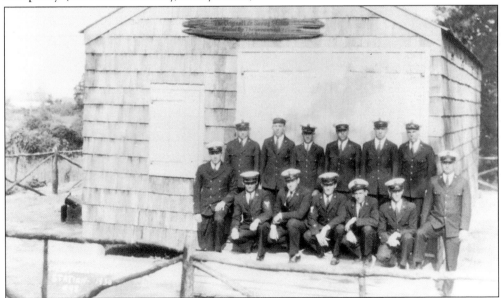

The crew of the Spermaceti Cove Station Number 2 is seen in this c. 1930 view in front of the boathouse, which is believed to be the only survivor of the 1849 life saving buildings. It had been located adjacent to the present visitors' center but was moved in 1954 to Twin Lights in Highlands, where it is still on exhibit. (Collection Gateway, Sandy Hook.)

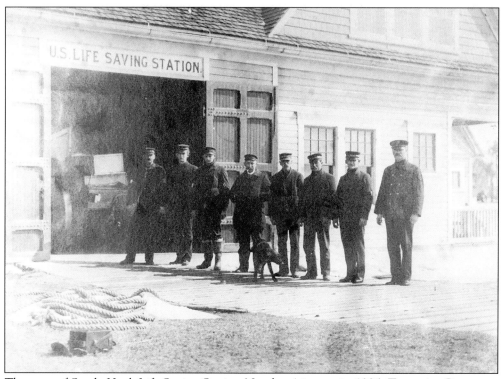

The crew of Sandy Hook Life Saving Station Number 1 is seen in 1906. Trevonian Patterson, keeper in charge, is at right. (Collection Gateway, Sandy Hook.)

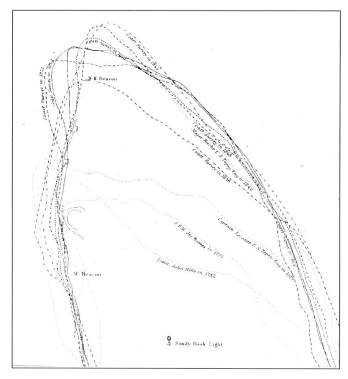

The centuries-old process of land accretion at the north end of Sandy Hook is illustrated by this 1855 map, believed to be from a government report, showing the tip's contours on several surveys dating from 1779. The process continued. The Long Branch shore was lined with high bluffs in the mid-19th century, but they eventually disappeared, much of their sand having been deposited at the Hook. The lengthened distance from the northern shore of the Sandy Hook Lighthouse necessitated the erection of the North Beacon. (Collection of Keith Wells.)

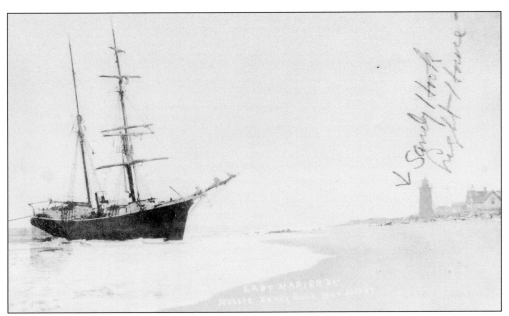

The British brigantine *Lady Napier*, running from Demerara, South America, to St. Johns, New Brunswick, with a cargo of iron, ran aground near the north tip of the hook on November 30, 1907. The crew was removed the next day, while the vessel was pulled off by wrecking tugs on December 6 and towed to New York. The penciled notation on this postcard failed to note the structure is the North Beacon. (Collection of John Rhody.)

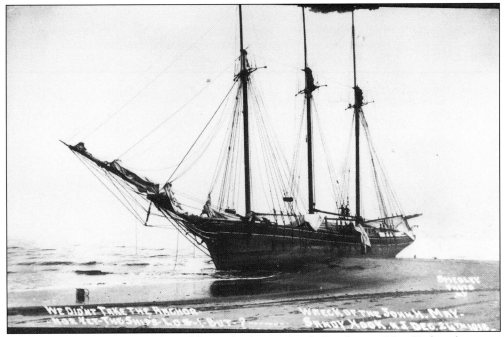

The *John H. May*, a schooner bound from Charleston, South Carolina, to New York with a cargo of lumber, ran aground at the tip of the hook. Although the vessel is described as a "wreck," it does not appear in very bad condition on this Smedley photographic postcard, at least to the admittedly landlubber author. (Collection of John Rhody.)

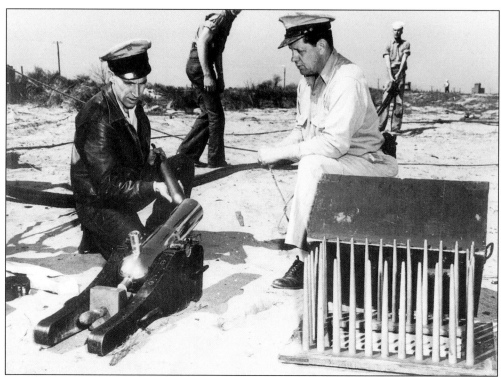

A line-throwing gun, invented by Lt. David A. Lyle of the Army Ordnance Department, was an early and effective life saving device; this type was in use into the 1960s. Tested at the Sandy Hook Proving Ground in 1877, the small bronze cannon could shoot a line over 500 yards to make contact with a ship in distress. Elmer Henfy is seen with the gun in a c. 1940 drill. (Collection Gateway, Sandy Hook.)

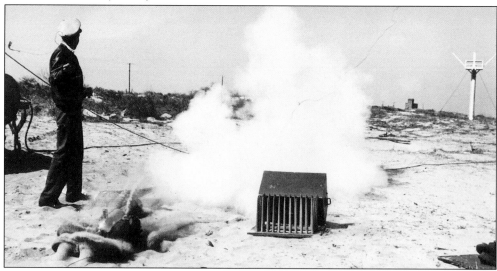

The lifesavers hoped the line would fall over the ship and be affixed by the crew to an object. After that, the surfmen would connect another line and other equipment to the shot line, which, when connected per instructions, permitted the sending of a hawser line, to which would be attached a breeches buoy. (Collection Gateway, Sandy Hook.)

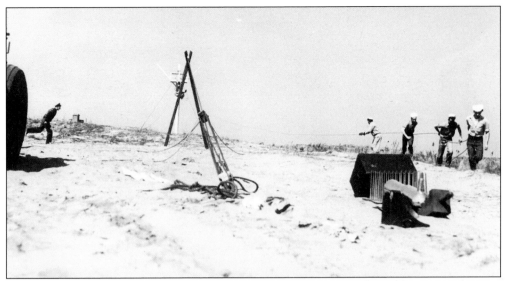

A volunteer is being hauled to shore in this breeches buoy, an open device that exposed one to the elements and made a trip to shore in rough seas and weather a harrowing experience. A life car (a metal-covered boat) could also be attached to the hawser. It weighed about 200 pounds and increased the strain on the line, but it could haul five or six people in an enclosed container in one trip. (Collection Gateway, Sandy Hook.)

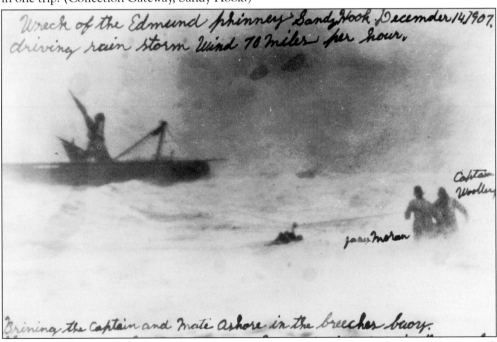

The *Edmund Phinney* was, according to *Broken Spars, New Jersey Coast Shipwrecks 1640–1935,* probably the last true bark wrecked on the New Jersey coast. Disabled about one mile from shore in a gale, the ship was initially beyond the reach of the Lyle gun, but it drifted closer to shore. A line was shot over it and affixed to the crumbling ship, enabling the crew to be carried out in pairs on the breeches buoy, through—rather than over—the surf. (Collection Gateway, Sandy Hook.)

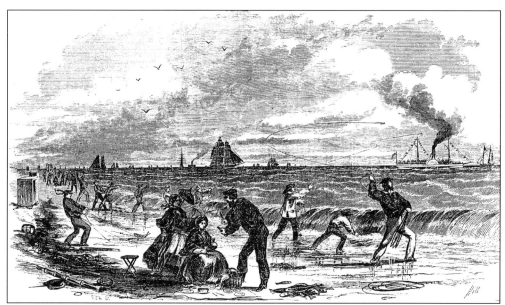

Sandy Hook waters were a fishing ground from Colonial times. George Washington was known to make excursions there. *Ballou's Pictorial Drawing Room Companion* of May 16, 1857, described the pictured method of surf casting for blue fish as unique to the area. The fisherman tossed his line toward the breakers and ran, pulling it once he made a strike. Yes, the fish could prove elusive on landing then, too. *Ballou's* specified that the number of illustrated vessels was not exaggerated, as all New York Harbor traffic passed Sandy Hook.

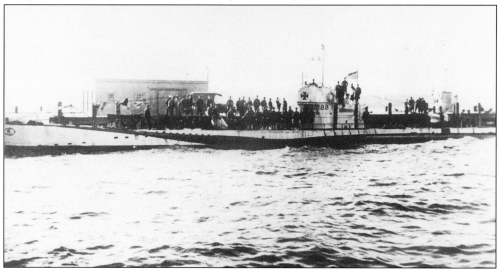

Several German U-boats, taken as war reparations, were sailed to the United States in 1919 for exhibition tours to promote the sale of Victory Loan bonds. The UB-88, a smaller submarine, and another are seen at the Sandy Hook dock in this view, probably photographed in May 1919. A *Register* news item that month indicated that the purchase of a $500 bond would entitle one to tour the interior of the vessel, which was then docked at Atlantic Highlands. No details were found about the Sandy Hook visit. As suggested by the clothes hanging on a line at left, one presumes a dive was not in this sub's immediate plans. (Collection Gateway, Sandy Hook.)

Two

FORT HANCOCK

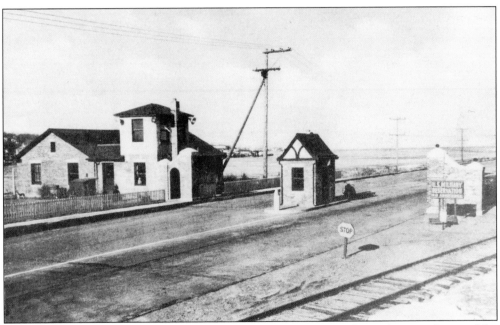

The entrance to the closed fort is seen at South Beach c. 1942, not long after completion of the gatehouse at left. The brick, end-gabled building with the tower still stands, but the pedestrian arch, railroad tracks, and guardhouse were removed. The latter, an irresistible target for motorists c. late 1970s to early 1980s, was taken down for safety reasons after repeated collisions. The building is now an office and break room for the fee booth personnel. See the next page for a later view of the gate area. (Collection of John Rhody.)

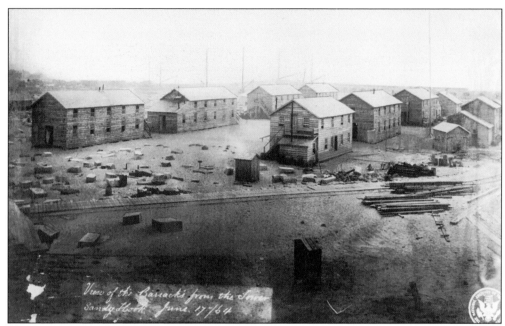

The earliest plans for fortifications pre-date the Civil War. The first construction was a wharf, built in 1857 at the north end to handle the arrival of construction materials. The barracks in this 1864 view were built near the wharf in 1858 to house the workers and, later, the soldiers. The buildings were taken down at an unknown date; some survived into the 20th century. The Roman Catholic Church has had a presence at Sandy Hook since 1857, beginning with its ministry to construction workers through visiting priests. By the turn of the century, a Catholic chapel was located in the northwest building of these barracks. (Collection Gateway, Sandy Hook.)

Privately owned cottages once lined the shore to a point abutting the government's property. Their presence is suggested by this c. late-1930s view showing part of one at left. Only one cottage remains (see p. 122). It is presently used as a residence for a park employee. (Collection Gateway, Sandy Hook.)

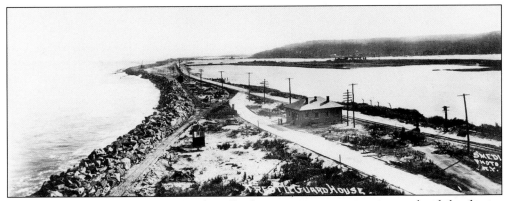

The Trestle Guard House monitored traffic from a vantage point just north of the former railroad trestle near today's parking lot C. It was made obsolete by the main gatehouse, which monitored all traffic. The removal of this structure may date from World War I, when security was presumably enhanced. At least one April 1917 press account describes lackadaisical, almost non-existent, security at the grounds' entrance. Plum Island is the narrow strip at right, while the hills of Highlands are in the background. (Collection Gateway, Sandy Hook.)

Photographer Thomas Smedley (1860–1947) created a large, stunning body of work at Sandy Hook c. 1905–1915. His photographs were printed in various formats, including photographic postcards, a medium that circulated the imagery of the area to a wide public. His name, often printed on the bottom corners of his pictures, can be noticed throughout this volume. He is known to have had a New York studio and is believed to have died in Jersey City, but little biographical information has been found. (Collection Gateway, Sandy Hook.)

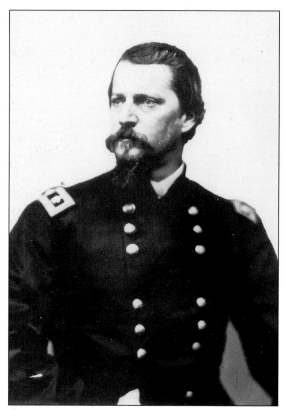

Winfield Scott Hancock, born 1824 in Pennsylvania, was an 1844 graduate of West Point who served with distinction in the Mexican War. He was appointed a brigadier general of volunteers at the outbreak of the Civil War. Later, he spent much of the war as head of II Corps of the Army of the Potomac. Hancock helped prepare the defensive position at Cemetery Ridge at Gettysburg and was wounded in that battle. His masterful work there earned his stature as one of the great soldiers of the Civil War and the thanks of Congress in 1866. Hancock's post-war commands as a major general, including the military division of Louisiana and Texas, embraced an administrative posture of supporting local rule that endeared him to the Democratic party. He narrowly lost the presidency as their candidate in 1880, returned to military service, and died in 1886. The fort was named for him in 1895. This c. 1864 portrait by Matthew Brady is in the Library of Congress. (Collection Gateway, Sandy Hook.)

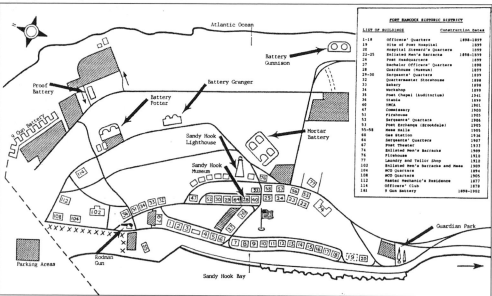

Each of the named places on this contemporary diagram is included in the book, as are many of the numbered buildings. Proof Battery is in Chapter Three, while the other batteries are featured in Chapter Four. The lighthouse is seen in Chapter One, and the numbered buildings are featured primarily in this chapter, which provides a general view of the fort. The flag is on the parade ground, which appears on p. 30 and elsewhere.

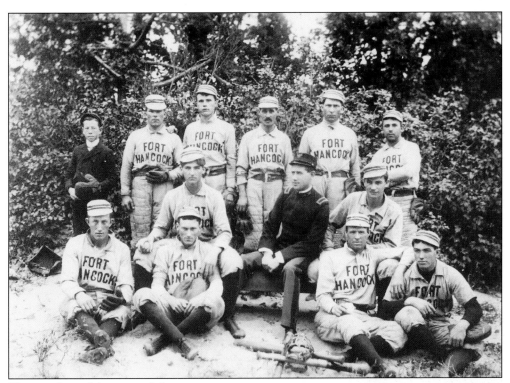

The members of this turn-of-the-century baseball team are unidentified. Note what appears to be protective equipment over the pants of three of the standing players. Bats in pictures of this period were typically crossed, but perhaps their parallel arrangement is "the Army way." (Collection Gateway, Sandy Hook.)

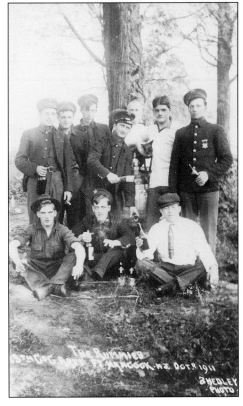

Smedley's work included a variety of genre scenes capturing everyday life at the fort. This 1911 picture is likely humorous pretending, as alcohol restrictions were usually severe. The example that follows is a childhood memory from that time recounted by the daughter of the "victimized" employee. Soldiers visiting a civilian worker at the water pumping station, a man known to have a "bottle," solicited a drink on a cold winter's day. His accommodating them was met with the revelation that the eager "drinkers" were part of a security detail. The army's punishment was the loss of his job and expulsion of the family from the Hook. (Collection of John Rhody.)

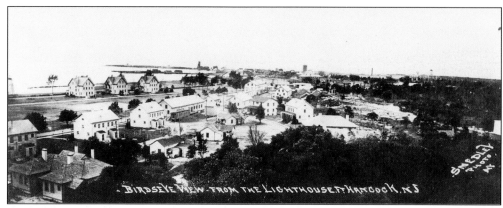

This *c.* 1910 view from the lighthouse looks north, with the Western Union telegraph tower and water tank being the vertical rises on the left and center (background) respectively. Officers Row and Sandy Hook Bay are at the far left. Sergeants Row barracks are visible at left, in front of a long, end-gabled building that was a former commissary; it was most recently used for storage of park collections. The small houses in front were owned by sergeants, who would sell them to others upon their reassignments. (Collection Gateway, Sandy Hook.)

A closer look at Sergeants Row on the east side of Kearney Road is seen in a *c.* 1920s photographic postcard. This scene is north of the former guardhouse and present museum (see p. 121). The buildings are now occupied as housing for Park Service personnel. (Collection of John Rhody.)

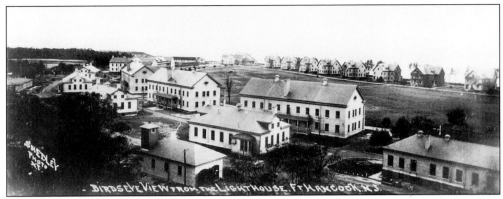

The southerly view from the lighthouse, the companion to the one at left, shows from background to middle ground Officers Row, the parade grounds, and the four large barracks buildings numbered 22–25. The former post exchange at right is now occupied by Brookdale Community College. A firehouse is at left in front of a mess hall. The former hospital is the last building in the background (part of the row at right). It is also seen on p. 44. (Collection Gateway, Sandy Hook.)

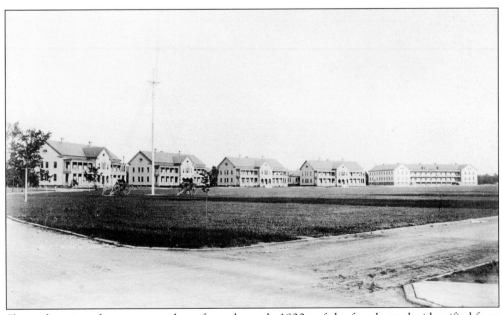

Shown here is a closer view, perhaps from the early 1920s, of the four barracks identified from left as Buildings 25, 24, 23, and 22. The long building at right, Building 74, was built in 1909 as barracks; it was the hospital annex in the World War II era and is now the James J. Howard Marine Sciences Laboratory. (Collection Gateway, Sandy Hook.)

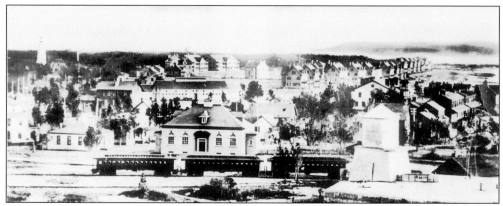

The lighthouse at left and Officers Row at right (background) help establish a perspective for this early-century view from the south end of the Hook. The proving ground train is parked in front of the laboratory, which is now a recreation building on the Coast Guard property. The southwest bastion, or corner, of the Civil War fort is visible in the lower right corner. Its water tower was replaced in 1910 by a structure that still stands today. The Civil War barracks (p. 22) are behind it, to the right. (Collection Gateway, Sandy Hook.)

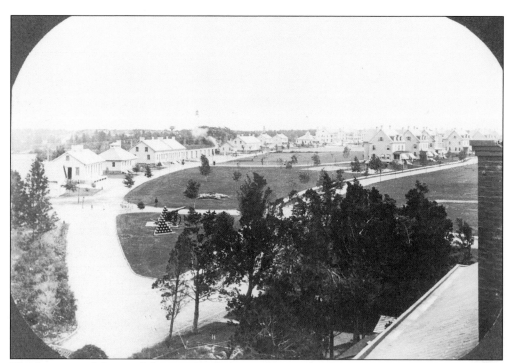

The former workshop at left, now the firehouse, has a contemporary prominence on Kearney Road. The small, square bakery separates it from the long, end-gabled quartermaster's hall. The lighthouse in the background and Officers Row at right help identify this c. 1900 elevated view. (Collection Gateway, Sandy Hook.)

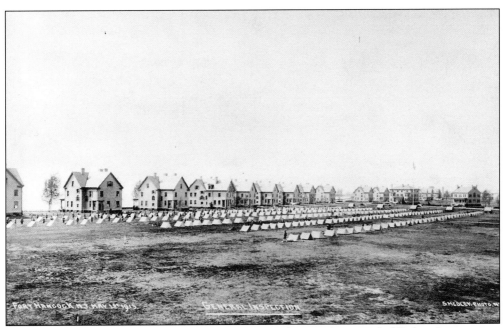

Two Smedley views show, from opposite directions, the parade grounds filled with pup tents. This one, looking northwest, is dated for a May 1, 1913 general inspection. The small tents provided field shelter for two men; each carried half. (Collection Gateway, Sandy Hook.)

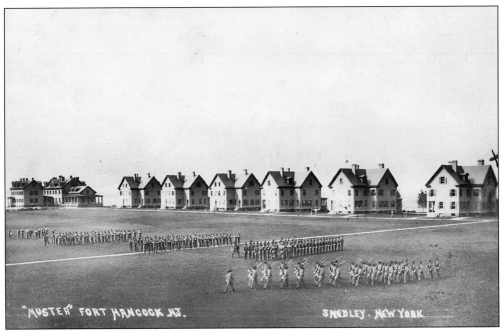

A muster on the parade ground is viewed c. 1912 in front of Officers Row, the most recognizable of Sandy Hook's buildings, and the post hospital at left (see p. 44). The main parade ground was named Pershing Field around 1960. (Collection of John Rhody.)

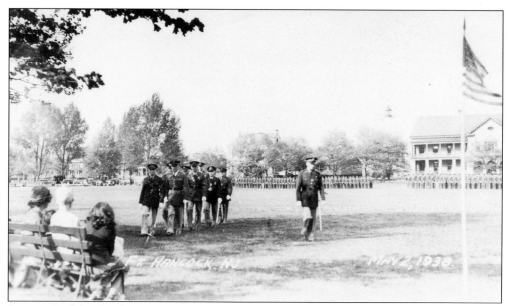

Battery C of the 52nd Coast Artillery is lined up in this 1938 photo for a review. It was likely a formal one, judging by the post commander's sword. His staff is adjacent to him, along with a few spectators. (Collection Gateway, Sandy Hook.)

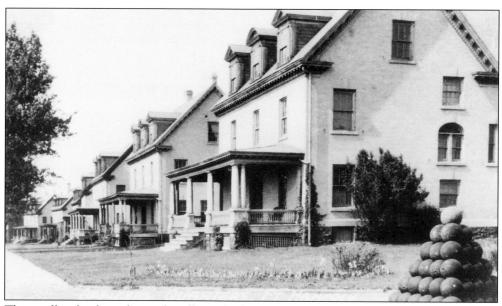

These yellow-brick residences for officers, built in 1898–1899 in a line along Hartshorne Drive known as Officers Row, were planned according to a sketch by Army Capt. Arthur Murray. The plans were drawn by Quartermaster Corps draughtsmen. This c. 1920s view looks north from Building 18, which was the farthest south. Building 1 is presently occupied as the History House Museum. Many of these buildings are becoming available for public occupancy under a Historic Leasing program that will make a prospective occupant's rehabilitation plans part of the consideration for their lease. (Collection of John Rhody.)

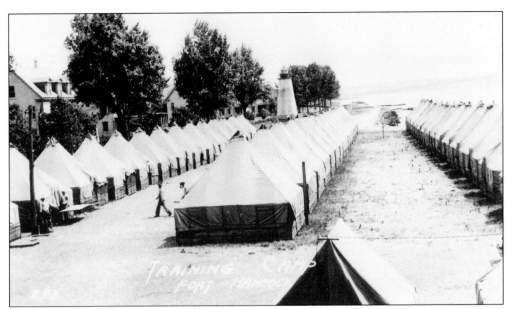

Fort Hancock was often dotted with tent camps that were used as temporary quarters. This c. 1920s postcard shows a Citizens Military Training Camp laid out in front of the West Beacon. The program, which may be likened to the summer camp element of military reserve training, was carried out between the world wars to provide a modicum of preparedness during an era of severe constraints on military expenditures. (Collection of John Rhody.)

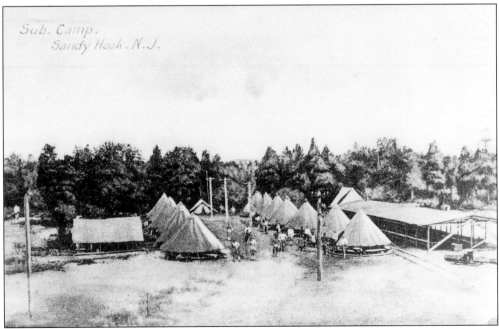

This sub, or subsidiary camp, provided shelter for military forces, perhaps in the World War I build-up period. It is one of several, with its location being difficult to pinpoint in the absence of recognizable landmarks. The long tent at right was an open-air mess hall. (Collection of Michael Steinhorn.)

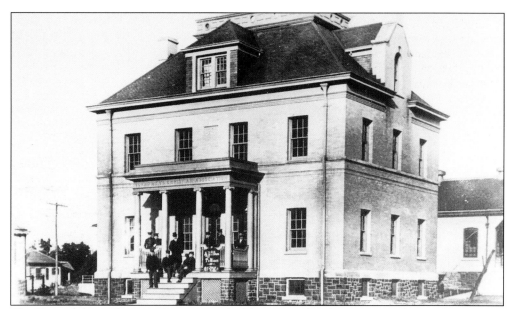

The Young Men's Christian Association building, completed in 1903 on the southern end of Kearney Road, is featured on this c. 1910 postcard. A 1901 date stone in the facade suggests that earlier construction was anticipated; it was delayed by governmental bureaucracy. The building contained a library, reading room, pool tables, and other typical recreational facilities. The structure was expanded in 1941 with the addition of a gymnasium on the north (left). The building now houses the Fort Hancock Post Office, a station of the Highlands office. (Collection of Michael Steinhorn.)

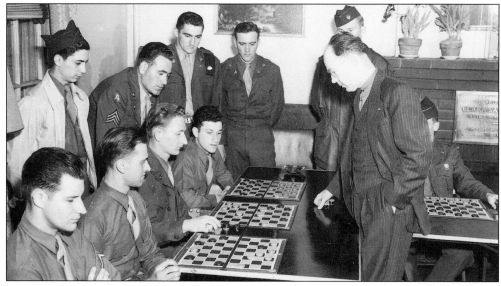

A series of simultaneous checker matches appears to be underway in this World War II–era scene at the YMCA. The plaque on the fireplace, on the north side of the building, provides a contemporary link between present and former occupancies. It still exists, and reads as follows: "This Building is the gift of Clara Sayles Gladding to young Men of the Army 1901. The Gift of God is Eternal Life in Jesus Christ." The building was a memorial gift by her husband. Historical photographs line the interior today. (The Dorn's Collection.)

Building 26, the fort headquarters, is seen here in 1912. It was built in 1899 on the north side of Hudson Road (a street that makes a division in Officers Row) and remains a headquarters building that today houses National Park Service offices. The second-story balustrade is gone, but the building is well preserved. The lawn signs, if painted today, would probably emphasize the word "off," which is hardly visible in this view. Tall sycamores now stand nearly as high as the building. (Collection Gateway, Sandy Hook.)

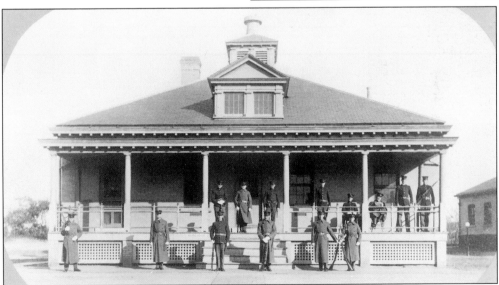

The guardhouse, Building 28, was built in 1899 at the south end of Kearney Road. The soldiers in this undated photograph, probably taken early in the 20th century, appear to be members of a guard detachment. The building, now the Sandy Hook Museum, preserves its lock-up, a space that still conveys a stark, cold, discomforting ambiance. This classic picture is foreshortened by a wide-angle lens, which makes the building appear larger than it actually is. (Collection Gateway, Sandy Hook.)

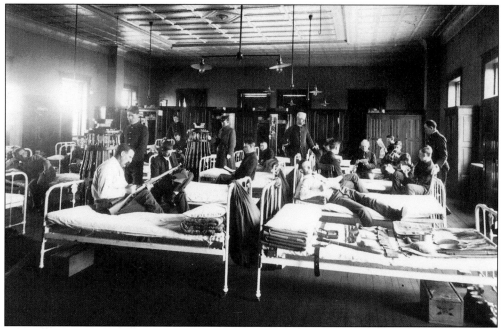

Soldiers of the 55th Company are shown c. 1905 in one of the similar barracks, Buildings 22 through 25, which are shown on p. 27. The scene appears formal and posed but conveys the closeness of the quarters. (Collection Gateway, Sandy Hook.)

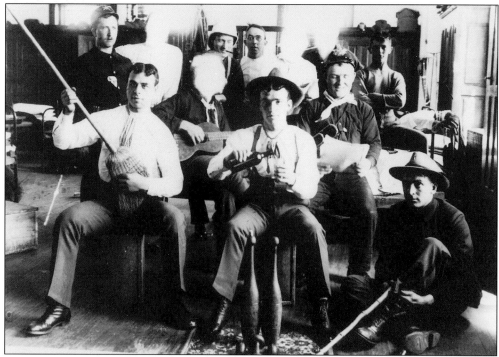

A second c. 1905 view in the same barracks row shows a group more at ease and is better reflective of the soldiers' desire to spend off-hours having some fun. What is the soldier in the center drinking, and why are they wearing hats indoors? (Collection of Gateway, Sandy Hook.)

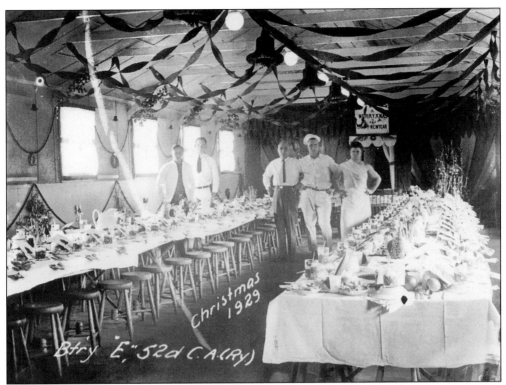

Christmas 1929
Btry "E" 52d C.A.(Ry)

The mess hall during Christmas in 1929 was festive for Battery E of the 52nd Coast Artillery, but seating does not appear comfortable or ample. One hopes that right and left-handed diners did not adjoin in the middle of those tight rows. (Collection Gateway, Sandy Hook.)

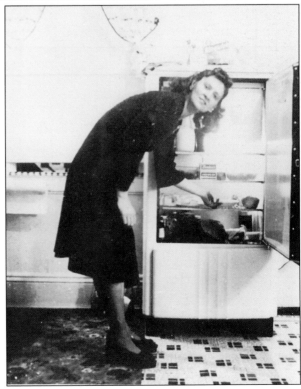

Mrs. Fred Schneider is seen c. 1944 in the kitchen of Building 29-B, a Sergeants Row house (see p. 26). Her husband, a member of the 245th Coast Artillery Regiment, was a plotter at Battery Kingman. He was one of the few who had the good fortune to serve the war years so close to home. (Collection Gateway, Sandy Hook.)

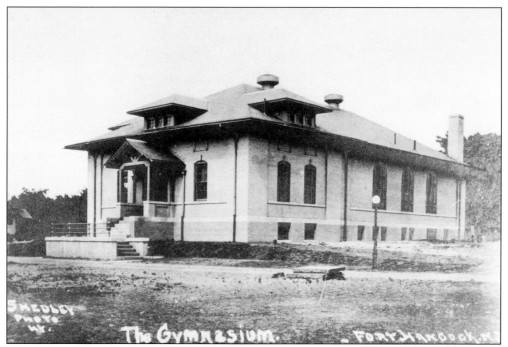

The Gymnasium, built in 1909 west of the lighthouse, was converted to the fort post exchange in 1941, when the gymnasium addition to the YMCA was made (see p. 32). This Smedley photographic postcard of Building 70 dates from *c.* 1912. (Collection of Michael Steinhorn.)

A partial view of the building at top is seen in 1950, during its post exchange period. The building now stands vacant. (The Dorn's Collection.)

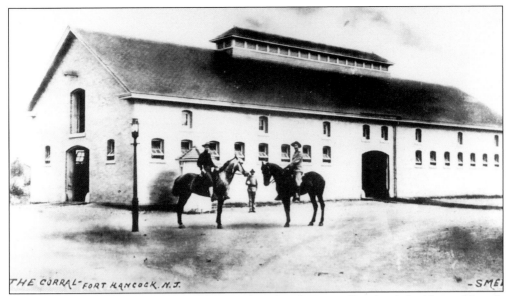

The "Corral" appears to be a fanciful name for a handsome, yellow-brick building, although it was one with a prosaic function as a stable for horses and mules. Built in 1899 at South and Kearney Roads, it was designated Building 36. This photo was taken *c.* 1912. The U.S. Army had varied uses for the animals in that period, maintaining a mounted cavalry (although not at Sandy Hook) until just prior to World War II, while mules carried mountain artillery guns, among other functions. (Collection Gateway, Sandy Hook.)

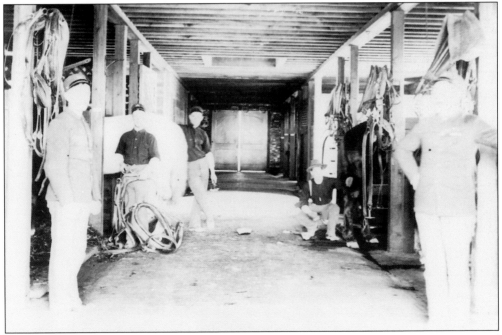

An interior view of the stables is seen early in this century. The building served its original function in the recent past as housing for Park Service horses, but the equestrian program was ended in 1998. The locale of the now-vacant building is immediately east of the Rodman Gun. (Collection Gateway, Sandy Hook.)

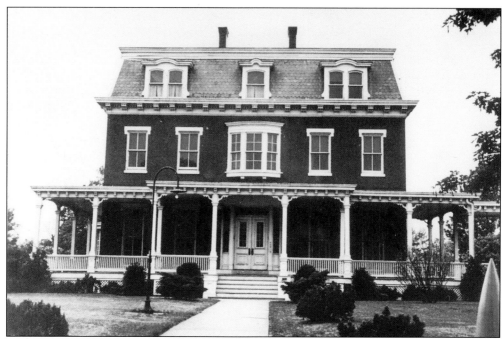

Building 114 was erected in 1878, north of Bragg Drive, at the height of popularity of the Second Empire style. It housed proving ground officers until the grounds were relocated in 1919. This building, the second oldest masonry structure on the Hook (after the lighthouse), was later the Officers Club. This picture is from the late 1930s. (Collection Gateway, Sandy Hook.)

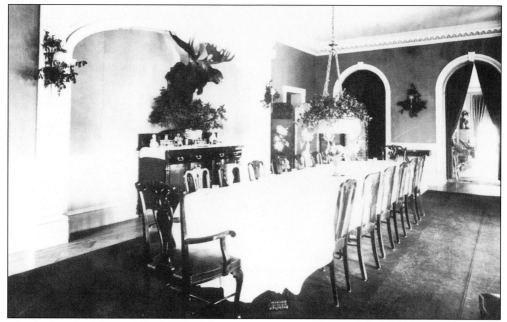

The dining room of the building at the top of the page is shown here at the turn of the century. The building was a park employees' dormitory c. 1970s and early 1980s, but the building, no doubt lacking adequate insulation, is now vacant. (Collection Gateway, Sandy Hook.)

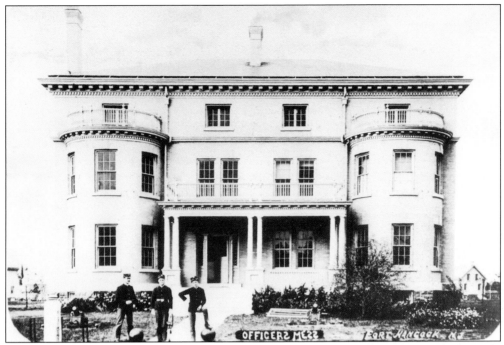

The Bachelors Officers Quarters, or BOQ, Building 27, was built in 1898–99 on the north side of Hudson Road, near the break in Officers Row and adjacent to the headquarters building (p. 33). This postcard image dates c. 1907, but another one from the late 1930s shows lieutenants' names painted on the stairs, suggesting an occupancy by eight officers. The Fort Hancock Officers Club initially was housed on the first floor in the west tower. The building is now a dormitory for seasonal National Parks Service employees. (Collection of John Rhody.)

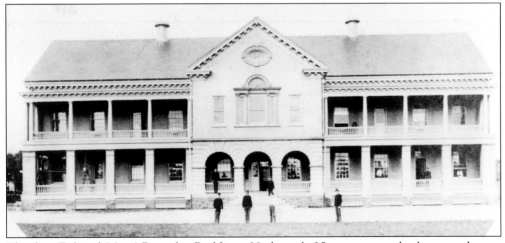

The four Enlisted Mens' Barracks, Buildings 22 through 25, are among the larger and more imposing residences in the fort. They were built in 1898–99, each with a mess hall on its south side and quarters for about 80 men. Their capacity was increased to about 109 in 1905, when separate mess hall buildings, Numbers 55 through 58, were built on the east side. The integrity of the buildings remains, although their condition has deteriorated. Two residences and two former mess halls will be available under the Historic Leasing program. This undated picture of an unspecified barracks is perhaps from c. 1905. (Collection Gateway, Sandy Hook.)

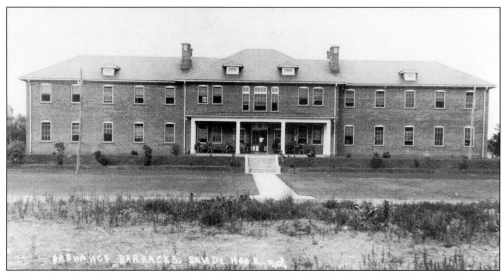

The large brick building at the north end, on the west side of Kearney Road, was built in 1909 as a proving grounds barracks. It later served Fort Hancock in a variety of occupancies, including housing a school for children in the early 1930s on part of the first floor. Seen on this *c.* 1912 photographic postcard, Building 102 is now an education center, accommodating overnight visitors, typically grades four through six, who are taking part in environmental programs. (Collection of John Rhody.)

The former Building 101 was erected in 1890 as a proving ground barracks for enlisted men. Located near the extant brick barracks at the top of this page, the frame structure was later divided into apartments for the families of enlisted personnel. Earlier family occupancy is suggested by the presence of women and children in this *c.* 1912 photographic postcard, created at a time when the post office was also housed here. The structure was demolished in the *c.* 1949 clearance of unneeded buildings. (Collection of Harold Solomon.)

The service club for privates and corporals, built in 1941 at today's Guardian Park, near NIKE, is seen in this undated image, perhaps from the mid-1940s. The building, designated Number 337, was a standard-style design built at many military installations. It was used for social functions after the war and was demolished in the early 1970s. (Collection Gateway, Sandy Hook.)

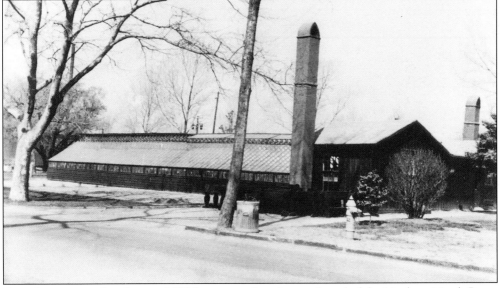

Greenhouses completed around 1904 once stood at the north end of the Hook on North Bragg Drive, just south of Building 114 (see p. 38). Flowers were their typical crop, used on tables and structure porches. One suspects vegetables may have been grown as well. Building 115 was connected with a second greenhouse; the chimney is visible behind it. The date the buildings were demolished is unknown. (Collection Gateway, Sandy Hook.)

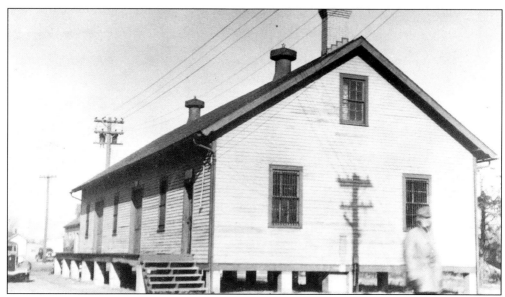

Building 50, a quartermaster's structure, was completed *c.* 1904 and is believed to have stood near present Building 47, the Kearney Road commissary (now a collection storage building). In the view from the lighthouse on p. 26, Building 50 is the small structure to the right of Building 47. It was demolished, probably in the late 1940s. (Collection Gateway, Sandy Hook.)

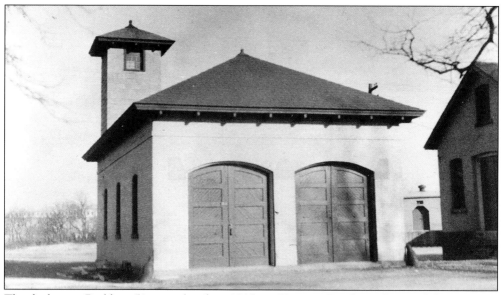

The firehouse, Building 51, completed in 1905 on Kearney Road, southeast of the Rodman Gun, was used by the army until 1974. The tower is now shingled and an extension has been built on the northeast corner. The army changed the opening to a single enclosure with an overhead door, which the National Park Service recently replaced. The Sandy Hook Fire Department now occupies the structure shown in this *c.* 1940 picture. (Collection Gateway, Sandy Hook.)

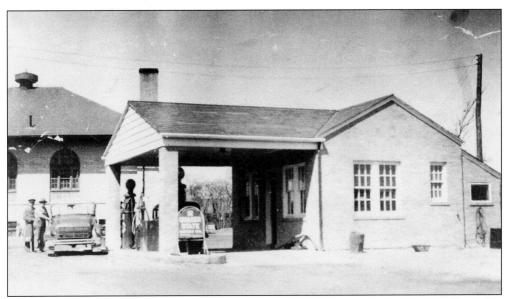

The post exchange gas station was built in 1936 adjacent to the PX (p. 36). It is partially visible at left, just west of the lighthouse. Designated Building 60, it operated until 1973. It is now vacant but well-preserved, still containing the air attachment at right and a sign that reads "Danger–Gasoline–No Smoking." Note the old-style gasoline pumps in this c. 1940 picture. (Collection Gateway, Sandy Hook.)

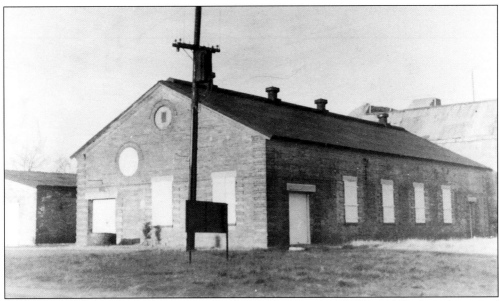

Central Power Plant Building 259 was completed in 1901, prior to the c. 1902 electrification of Fort Hancock. Located adjacent to Battery Potter, its dynamos, however, produced power for the Potter, Granger, and Mortar batteries, leading to speculation that other batteries had their own generating facilities. The picture is a c. 1940s view. (Collection Gateway, Sandy Hook.)

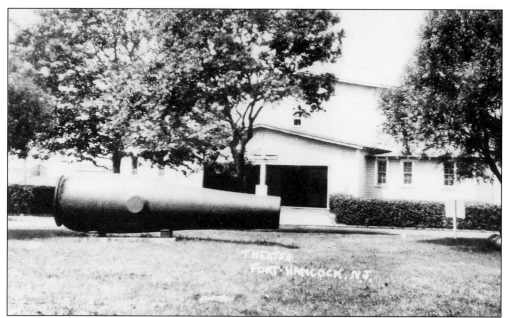

The Liberty Theater, built in 1918 for silent film and stage entertainment, was demolished upon the 1933 completion of the present theater (Building 67) at the junction of Kessler and Kearney Roads. Its site is now a parking lot west of Hartshorne Drive. The picture is a *c.* 1920s photographic postcard. Note the Rodman Gun on the ground; this was its placement until the 1937 construction of its present base by the Civilian Conservation Corps. (Collection Gateway, Sandy Hook.)

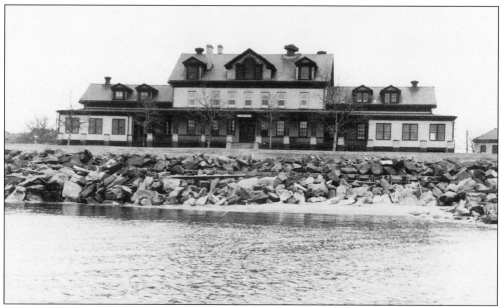

The post hospital, Building 19, was completed in 1899 on a site south of Officers Row. Its waterfront locale is evident in this undated view from Sandy Hook Bay. The building housed the fisheries laboratories when it was destroyed by an incendiary fire in September 1985. (Collection Gateway, Sandy Hook.)

This water-pumping station, now Building 341, was built in 1912 to replace a frame structure. The building stands near Horseshoe Cove, at the end of Randolph Drive, in an area closed to the public. Its stack is gone and its windows are bricked in. (Collection of John Rhody.)

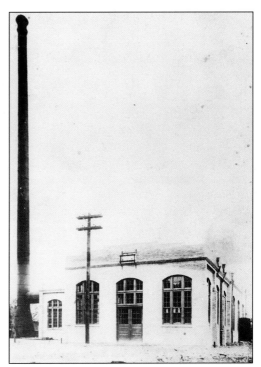

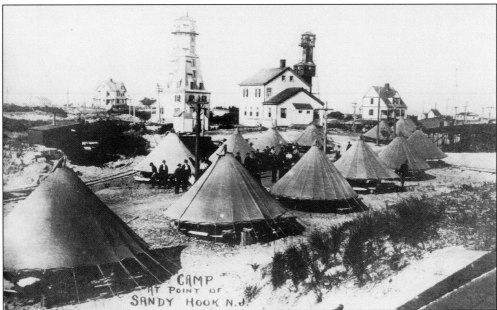

The Western Union telegraph tower is the readily recognizable structure left of center; at left is the engineers residence (see p. 51) that provides an extant point of reference for a much-changed area of the north end. The site of the small structure at far left is a Coast Guard parking lot. The scene may date from 1917, when wartime need brought tent camps and buildings were moved in this section, following the removal of the North Beacon (see p. 12.) Note the two-story, end-gabled structure in the center that appears to be positioned over tracks, perhaps in the process of moving. (Collection of John Rhody.)

45

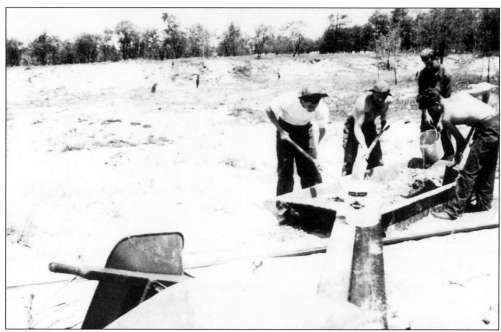

The Civilian Conservation Corps, which had a Fort Hancock camp from 1935 to 1938, found a list of deferred construction projects at the budget-strained facility. This crew is seen in 1937 mixing mortar for the existing Halyburton monument (see p. 11). (Collection Gateway, Sandy Hook.)

Several Civilian Conservation Corps barracks were located near Battery Arrowsmith, along with the smaller of two Fort Hancock blimp hangars. The barracks were demolished c. 1941, as they were too small for army use. This hangar may be the one that survived well into the 1950s before being demolished. (Collection Gateway, Sandy Hook.)

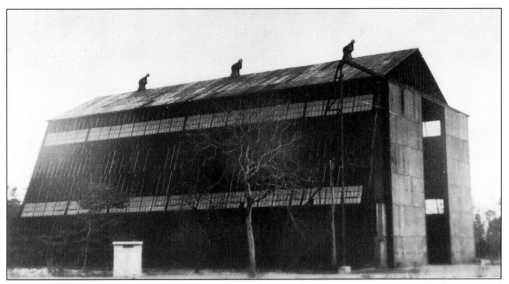

The larger blimp hangar, Building 99, was completed in 1921. It was constructed of corrugated sheet metal and located near the parking lot that is now adjacent to Horseshoe Cove. It is believed to have been demolished c. late 1940s. (Collection Gateway, Sandy Hook.)

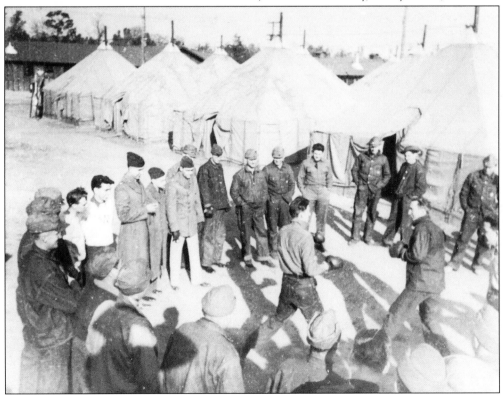

The 245th National Guard Regiment from Brooklyn was federalized into the army in 1940, becoming the 245th Coast Artillery Regiment. They occupied a tent city near Battery Gunnison while barracks were under construction. Some members are seen at a recreational boxing match during that period. (Collection Gateway, Sandy Hook.)

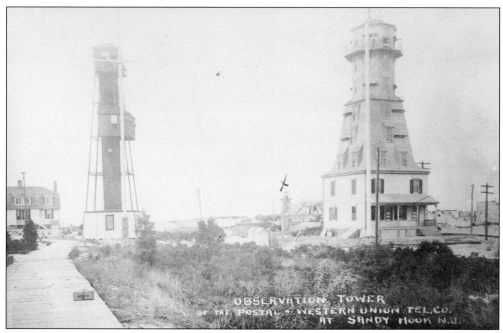

Shown on this *c.* 1910 postcard are the towers of the postal telegraph (left) and Western Union Telegraph Company (right). The handwritten "x" marks the location of the North Beacon (see p. 12).

This *c.* 1900 residence for postal telegraph workers and their families was one of the fort's more distinctive Colonial Revival structures. Note its roof treatment with a steeply pitched, hipped main block containing three shed dormers and the intersecting gambrel roofed wing at left. Located at the north end, west of the 1936 Coast Guard headquarters, the building is believed to have been quarters for non-commissioned officers in the post-telegraph period. It was demolished at an unknown date. (Collection Gateway, Sandy Hook.)

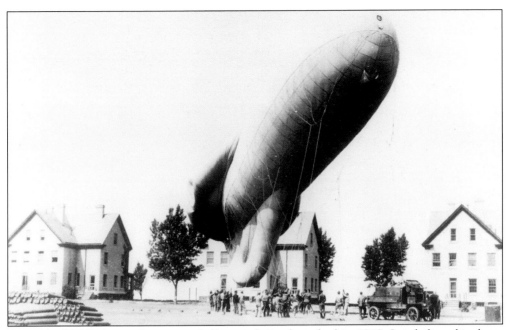

A standard U.S. Army observation balloon is being launched in 1919. It is believed to have been observing firing tests at Batteries Kingman and Mills. Shown here are the main parade grounds, with Officers Row in the background. (Collection Gateway, Sandy Hook.)

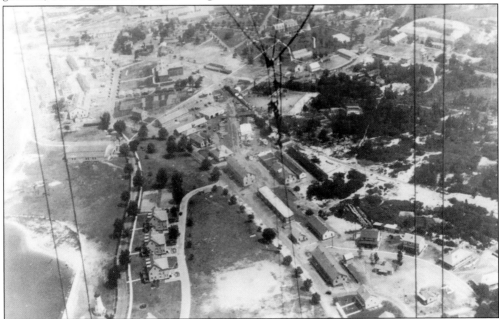

A camera on the observation balloon was an incidental sideline but provided a vivid aerial glimpse of the Hook, in this instance, the north end. The West Beacon is at left, in front of the site where an officers duplex building was later added in the midst of the 1898–99 Officers Row. The 1918 theater is the long building facing the street some distance above the beacon. Battery Potter is at top right, while Sergeants Row is at bottom right. (Collection Gateway, Sandy Hook.)

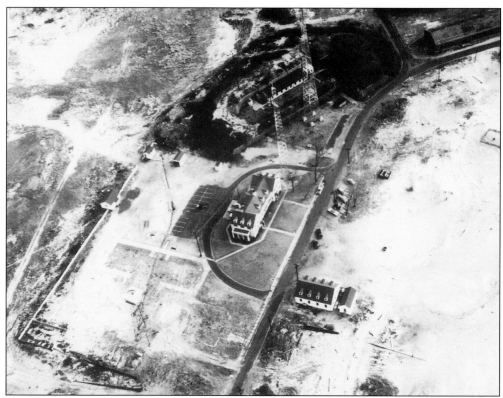

The "97" to the right of the road provided visual identification of the Sandy Hook Coast Guard station to pilots. It was part of a numerical identification system that followed the Atlantic Coast. The structure within the semi-circular drive, the 1936 Coast Guard headquarters, is also seen at bottom. The tall towers, part of a LORAN system, were built c. 1950. The boathouse and emergency generator buildings are seen at bottom. (Collection Gateway, Sandy Hook.)

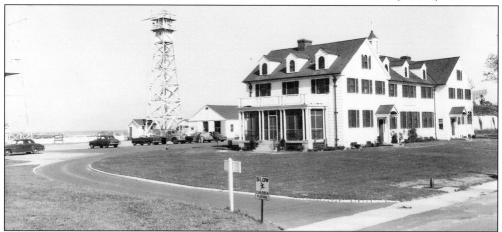

The architecture of the Coast Guard headquarters, built in 1936, is fascinating. The side at left creates the impression of a small, three-bay Colonial Revival structure, not unlike a house. The facade, however, is a larger main block, with the small "front" appearing as a wing, matched by one at the opposite side. The sea vista between the towers is now marred by dunes and wild vegetation. The view is c. 1950. (The Dorn's Collection.)

The former army engineers' residence, later the non-commissioned officers' quarters, was built c. 1892 on the north end. It features early Colonial Revival stylistic elements unlike other Sandy Hook structures, and possesses a hint of the Shingle Style that preceded it. The recently restored house, Building 526, still serves the Coast Guard as a residence. (Collection Gateway, Sandy Hook.)

The Fort Hancock wireless communication tower and building erected c. 1917 are seen in a c. 1920 photographic postcard. The Marconi system radio was used through World War II for communicating with regional army facilities. The tower is long-gone; the building stands in derelict condition, southwest of Battery Potter. (Collection of Harold Solomon.)

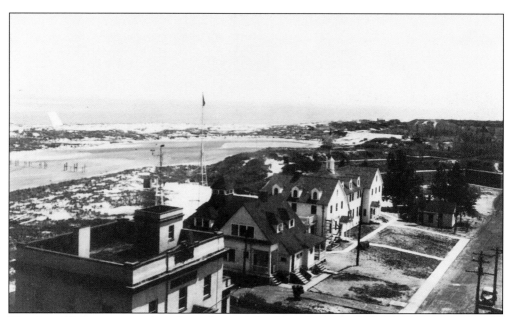

This late 1930s picture, taken from the postal telegraph tower, and its companion at right provide an ocean-to-bay panorama of the north end of the Hook. The one above shows the no-longer-standing Weather Bureau building (also at bottom) and Sandy Hook Life Saving Station Number 1 (see p. 14) in their former context. Also shown is an extant prominent landmark, the 1936 Coast Guard station. (Collection Gateway, Sandy Hook.)

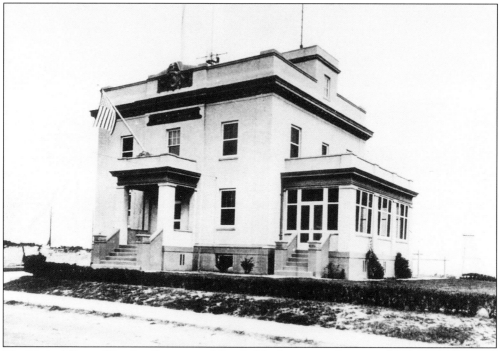

The United States Weather Bureau used Sandy Hook as a weather recording station for some time, occupying this building adjacent to the life saving station. It was demolished either in the late 1940s or early 1950s. (Collection Gateway, Sandy Hook.)

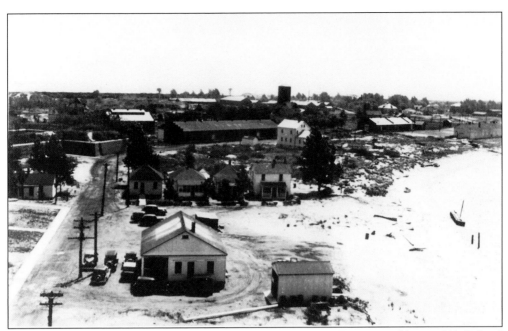

The maintenance building in the foreground has a "97" painted on its roof (see p. 50). Behind it are Coast Guard residences, and mine casemate walls are at left. A variety of warehouse and service buildings fill the background. The 1910 water tower is the cylindrical structure. (Collection Gateway, Sandy Hook.)

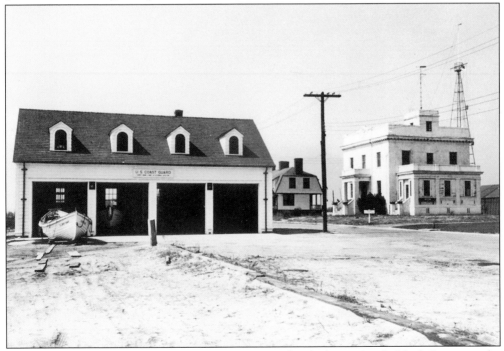

The Coast Guard boathouse is located adjacent to the docks on Sandy Hook Bay, near the headquarters building. This picture is perhaps from the 1940s. In the background is the postal telegraph residence seen on p. 48. (Collection Gateway, Sandy Hook.)

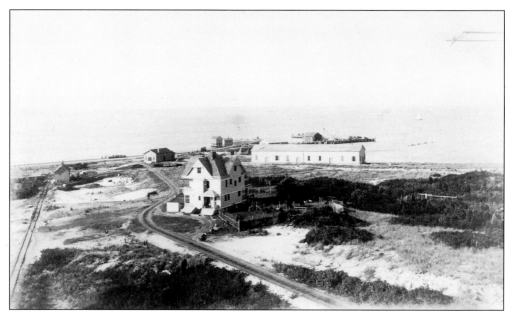

This undated, early view of the ordnance department wharf (background) and storage buildings shows the site of the present Coast Guard dock. Note the rail lines that ran from Sandy Hook Bay to the storehouse (left) and the underwater mine cable storehouse (see p. 104). (Collection Gateway, Sandy Hook.)

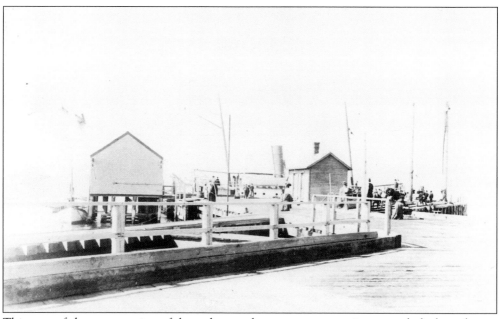

This turn-of-the-century view of the ordnance department, or proving ground, dock, embraces some of the structures visible in the image at the top of the page. These facilities were later replaced by the modern docks. (Collection Gateway, Sandy Hook.)

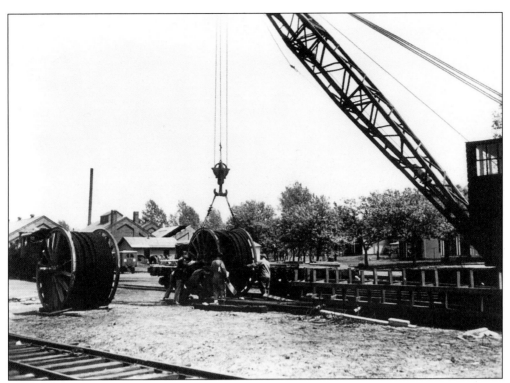

The railway crane lifting the cable was near the docks, but the wire is not identified. It could have been for underwater mines, power lines, or telephone purposes. (Collection Gateway, Sandy Hook.)

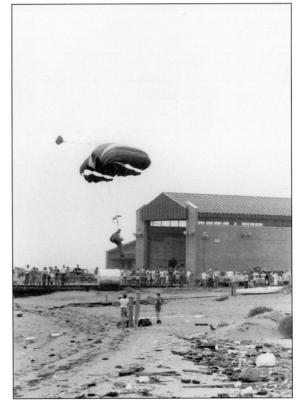

The Coast Guard's boathouse, built in the early 1970s, is seen at the Coast Guard's 188th anniversary celebration in August 1978. The structure contains a moving crane that moves vessels using straps and winches to place them on chocks for out-of-water repairs.

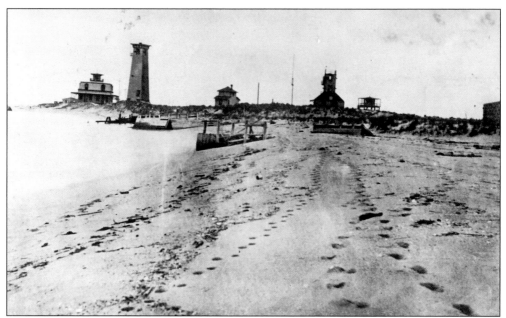

Beach erosion is not just a major environmental challenge of today, but it has been a problem for many years. Although accretions through tidal action have made major additions to the northern tip of the hook, this 1882 photograph and its companion below were taken to record erosion. The structures are the proving grounds office, the Western Union tower, their operators quarters, the United States Signal Service building, and a proving ground observation tower. (Collection Gateway, Sandy Hook.)

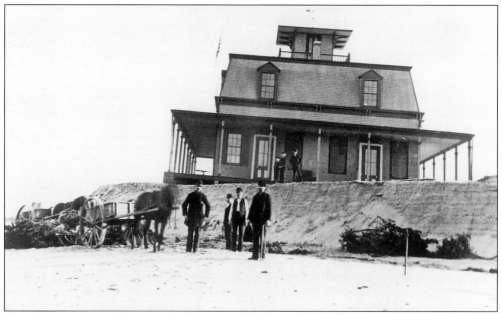

Note the proximity of a major building, the proving grounds office and instrument house, to the eroded shore. The activity at left is the placement of trees to facilitate a build-up of sand. Fire, rather than waves, caused the demise of this building following a lightning strike in 1889. (Collection Gateway, Sandy Hook.)

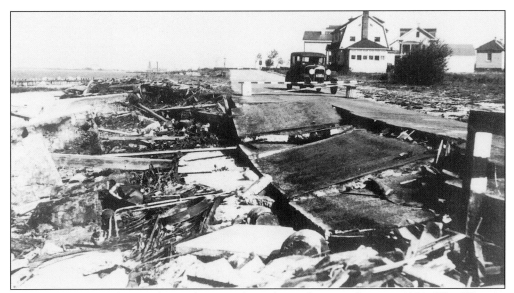

Storm damage on the Sandy Hook Bay side is shown here, perhaps in 1938. The Western Union and Postal Telegraph towers are in the distance, while Hartshorne Drive is the road cut off to traffic. The gambrel-roofed residence no longer stands, and the former hospital (to its right) was destroyed by fire in 1985 (see p. 44). The small structure at far right was the morgue; it is now a public restroom. (Collection Gateway, Sandy Hook.)

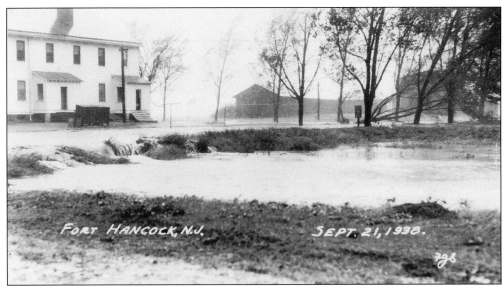

This 1938 hurricane flood scene was photographed around the north end, with barracks at left and a warehouse in the center. The buildings were demolished in the post–World War II period. A barracks building was later erected on the site of the puddle. This scene is near the chain-link fence that now separates the Coast Guard base from the park. (Collection Gateway, Sandy Hook.)

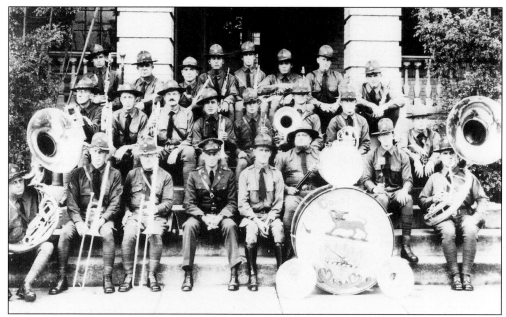

The band of the 7th Coast Artillery Regiment is seen *c.* 1930 in front of one of the barracks, Buildings 22 through 25 (see p. 27). The unit was stationed at Fort Hancock from 1924 through World War II. (Collection Gateway, Sandy Hook.)

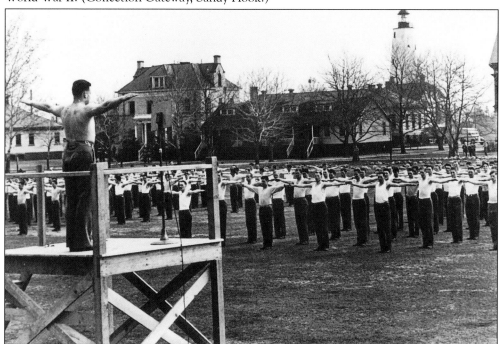

Lt. Thaddeus P. Flouyan of the 245th Coast Artillery is leading a calisthenics drill in the early 1940s on the main parade grounds. The YMCA is the tall building above the platform, while the lighthouse is at right. Physical conditioning has been an important concern ever since the armed forces learned in World War I that many recruits were unfit for the rigorous demands of military service. (Collection Gateway, Sandy Hook.)

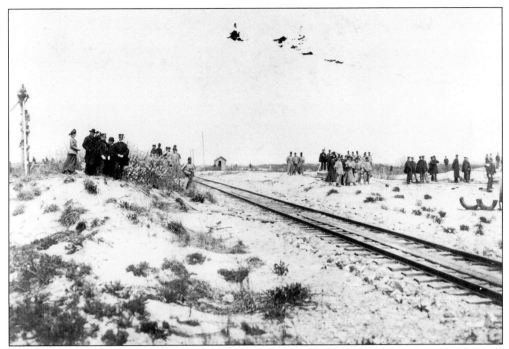

The first class (seniors) of the United States Military Academy are seen c. 1910 on a field trip to Fort Hancock. They went there for practical instruction in ordnance and gunnery. (Collection Gateway, Sandy Hook.)

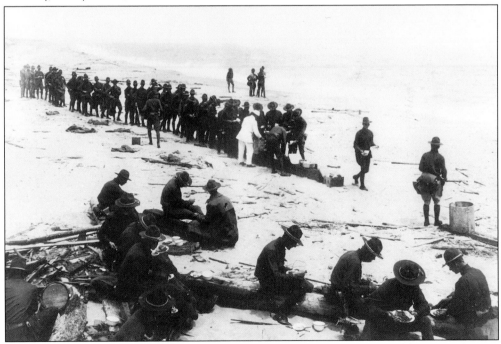

Chow time on the beach provides respite from some activity for this World War I–era crew. This scene is suggestive of a contemporary pleasure at the Hook, a summer meal on the beach or sea wall taken apart from a bathing excursion. (Collection Gateway, Sandy Hook.)

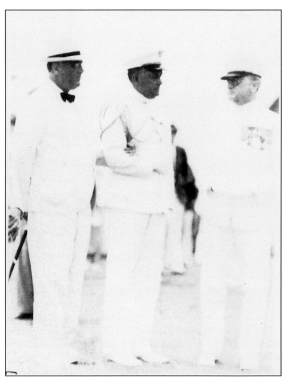

President Franklin D. Roosevelt was believed to be inspecting the fleet in the Atlantic in August 1939, arriving in local waters on the cruiser USS *Tuscaloosa*. He was transferred to the USS *Lang*, a destroyer that docked at Fort Hancock on August 24, 1939, creating an opportunity for this rare snapshot. The president, crippled by infantile paralysis, could not walk or stand unaided. Press photographers were scrupulous in observing a ban on photographs of the President while he required assistance. He was motored to Red Bank and proceeded to Washington via train. (Collection Gateway, Sandy Hook.)

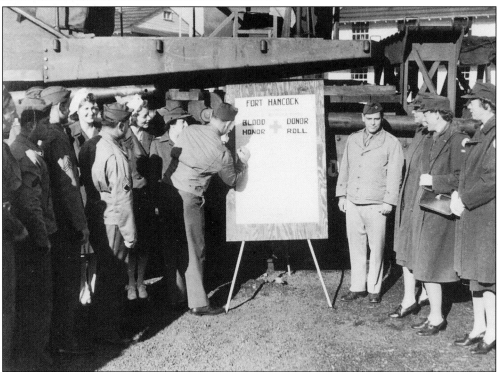

Battery F members are seen signing a blood drive honor roll. Here they are positioned in front of an 8-inch gun during World War II. (Collection Gateway, Sandy Hook.)

Fort Hancock's *c.* 1940 poll to select a favorite actress was won by Lana Turner, who accepted an invitation for a visit. She is seen on the parade grounds receiving gifts, while Colonel Wilson is at left. She completed her visit by eating with the soldiers and touring the base. (Collection Gateway, Sandy Hook.)

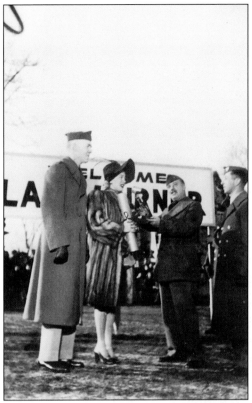

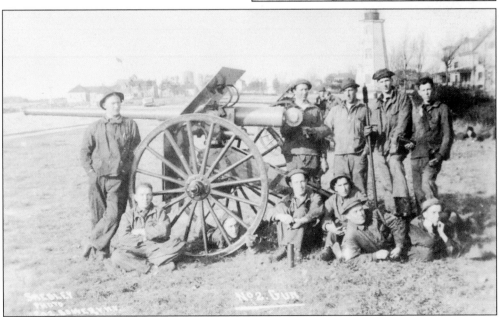

A crew is seen waiting to fire a field artillery gun, probably of 3-inch caliber, near the sea wall at Sandy Hook Bay. Note their attire—work fatigues and floppy hats. The guns were fired for ceremonial duties and daily, on the parade grounds, to signal the start of the retreat ceremony, or lowering of the flag. (Collection of Harold Solomon.)

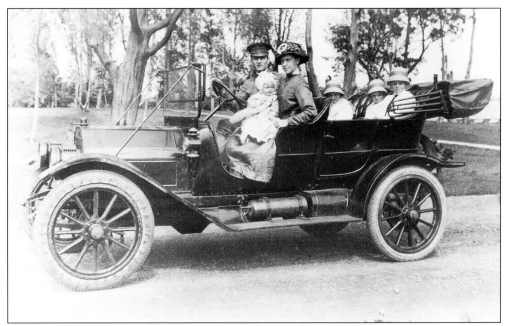

Sergeant Snodgrass and family pose in his automobile outside the greenhouse *c.* 1920. He was reportedly one of the first to have a car at Fort Hancock—and a right-hand drive at that. (Collection Gateway, Sandy Hook.)

If all uniformed members of this unspecified Fort Hancock football team were practicing a particular play, one hopes they learned to do it with only 11 men. The photographic postcard may be *c.* 1915. (Collection of John Rhody.)

Brig. Gen. Philip Stearns Gage, born 1885 in Michigan, was a 1909 West Point graduate. Gage, a career soldier in coastal defense, was promoted to brigadier general in 1940. He commanded New York harbor defenses from April 6, 1941, to March 2, 1944. (Collection Gateway, Sandy Hook.)

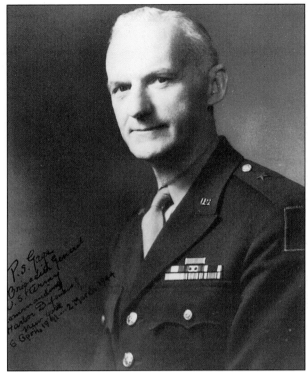

Lt. Gen. Hugh A. Drum (1879–1951) is seen landing at the dock to inspect Fort Hancock during a CPX problem. A command post exercise is a commander and staff workout of simulated combat scenarios without employing troops in the field. Drum, who entered the army in the Spanish-American War and was promoted to general in World War I, was a controversial figure through his later career. He was a strong proponent of preparedness and a vocal critic of those deemed responsible for many pre-World War II deficiencies. (Collection Gateway, Sandy Hook.)

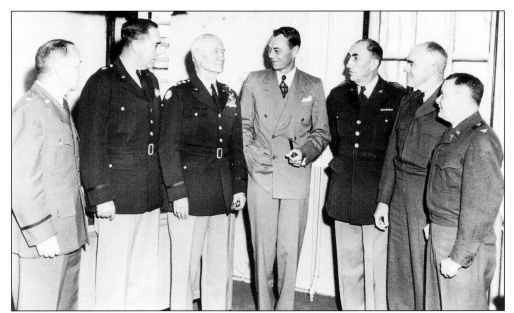

Post-World War II demilitarization resulted in the demolition of a number of unneeded buildings at Fort Hancock and the consideration of plans to close the base. The Korean War, however, gave renewed importance to the fort, which was employed as a staging and maintenance area for metropolitan New York air defenses. Under Secretary Archibald S. Alexander is seen visiting the base in October 1951. (Collection Gateway, Sandy Hook.)

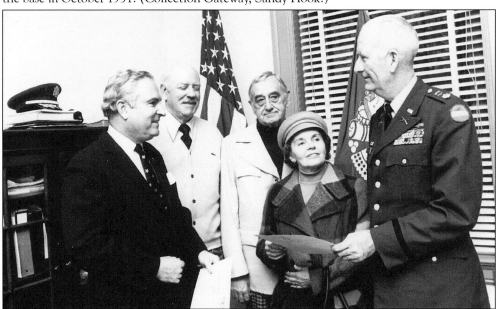

Lt. Col. Herbert S. Hayes (right) and four civilian volunteers were gathered for the final flag ceremony at Fort Hancock on December 31, 1974. Tom Hoffman recalled that a raging snow storm that day froze the halyard, preventing the lowering of the flag. Those honored, from left to right, were George H. Moss Jr., historical consultant and founder of the Sandy Hook Museum; Henry Haddon of Sea Bright, for volunteer work with Fort Hancock community projects; and Mr. and Mrs. Charles H. Gompert Jr. of Fair Haven, who worked at the museum.

Three

SANDY HOOK PROVING GROUND

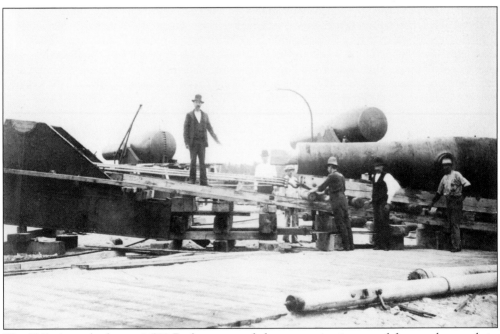

The U.S. Army had over 1,500 Rodman smooth-bore cannons in coastal forts and arsenals in the post-Civil War period. They sought ways to convert these cannons to rifled guns, weapons with grooves in their barrels to increase accuracy. Developing an effective rifling program was an early mission of the Sandy Hook Proving Ground. A crew of six is shown mounting a Rodman on a barbette carriage *c.* 1880, using ropes, rollers, and a pulley. The gun proved of limited utility, especially for the newly vital criterion of armor piercing. It was replaced by a modern, breech-loading, high-powered rifled cannon. (Collection Gateway, Sandy Hook.)

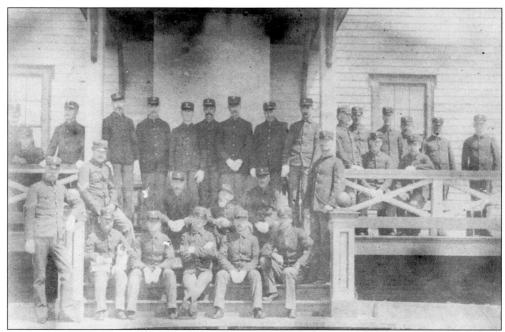

Big guns are among the best-known aspects of Sandy Hook's history. Less known is the distinction between the proving grounds, founded in 1874 to test weapons and ordnance, and the coastal defense facilities, the subject of Chapter Four. This c. 1890 picture is the earliest known image of an ordnance detachment. Note the frame buildings, which were built at a lower cost since Sandy Hook was considered for many years to be a "temporary" facility. The ordnance department finally declared Sandy Hook "permanent" in 1901. However, the range was always too short and in 1919, the army relocated to the present Aberdeen (Maryland) Proving Grounds. (Collection Gateway, Sandy Hook.)

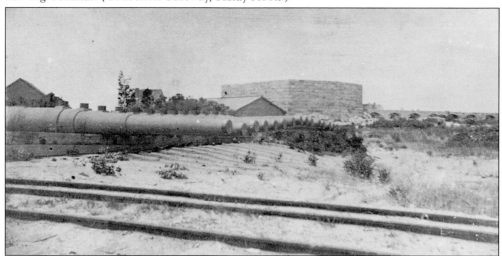

The original Proof Battery was located opposite the site of the south end of the extant Nine Gun Battery. A row of cannons suggests these are regular run guns made for army use, with each requiring testing for manufacturing flaws, or to see that "it works." A bastion, or corner, of the Civil War–era fort at Sandy Hook is in the background of this 1895 photograph. (Collection of Richard C. Winters.)

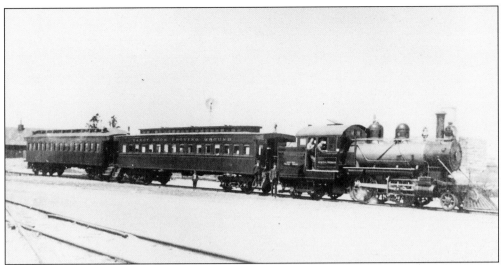

The Sandy Hook Proving Ground railroad ran a passenger train to the Highland Beach station in present-day Sea Bright to pick-up civilian employees. It returned in the evening to send them home. Such a train is seen in the early years of this century, pulled by the locomotive *General Rodman*. The railroad acquired the facetious name "B.N.F. Line," for "Back 'n Forth." (Collection Gateway, Sandy Hook.)

A series of steam boiler tests supervised by F.B. Stevens were successfully conducted at Sandy Hook in 1871, prior to the establishment of the Ordnance Proving Ground by the United Railroad Companies of New Jersey. A boiler that had been in maritime use for 25 years was also subjected to a number of high-pressure tests, repaired, and tested again until it exploded. The experiments, with the participation of the navy department and ferry operators, were helpful in revealing new information on boiler performance. The illustration and report were in the *Harper's Weekly* of December 23, 1871.

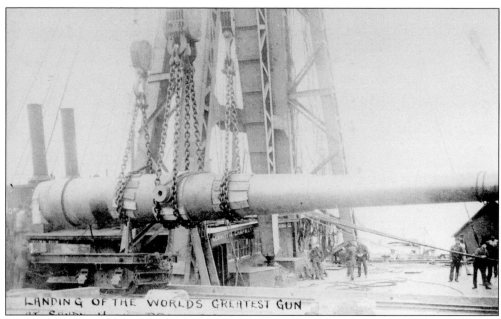

The manufacture of "The World's Greatest Gun" began in 1899 at the Watervliet, New York, arsenal. The gun was completed in 1902 and shipped to Sandy Hook by barge for testing. This powerful weapon with a 16-inch bore was considered an army prototype, but the costly gun never went into regular production. This one remained at Sandy Hook and was subjected to various tests until 1917, when it was moved to the Canal Zone, Panama. The 1902 picture was issued as a photographic postcard several years later. (Collection of John Rhody.)

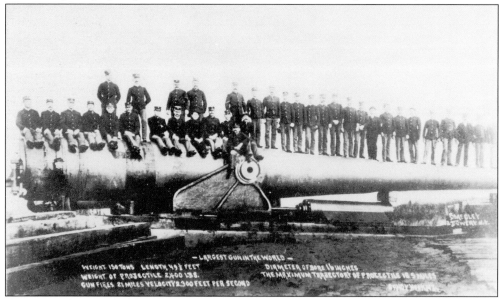

Posing for a picture on the 16-inch gun was a popular image and postcard at Sandy Hook. The published statistics vary slightly; this c. 1908 postcard claims the gun weighed 130 tons, with a length of 49.5 feet and range of 21 miles. The differing mileage listed on another postcard could have stemmed from a different powder charge. The tube underneath the barrel is a proof carriage for firing on the horizontal. (Collection of John Rhody.)

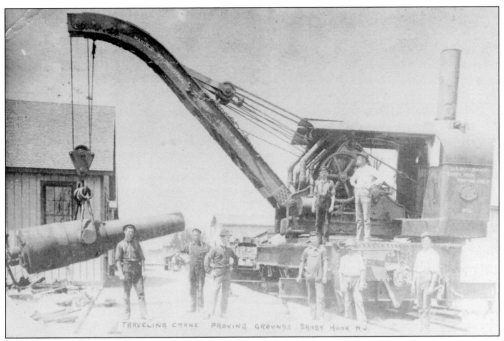

A 12-inc,h breech-loading rifled mortar is being unloaded at the pier c. 1910. The inexpensive, easy-to-build mortar was a favorite coastal defense weapon of the U.S. Army. (Collection of John Rhody.)

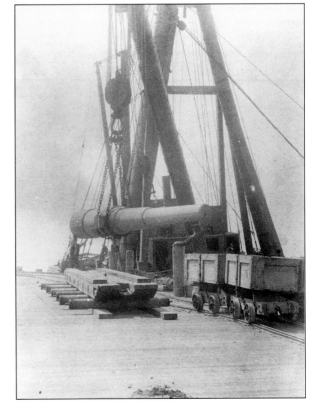

A large gun is unloaded c. 1905 at the proving ground dock. If this is the 12-inch caliber, it would have weighed 52 tons. Many of the guns tested at Sandy Hook were shipped from the arsenal at Watervliet, New York. (Collection Gateway, Sandy Hook.)

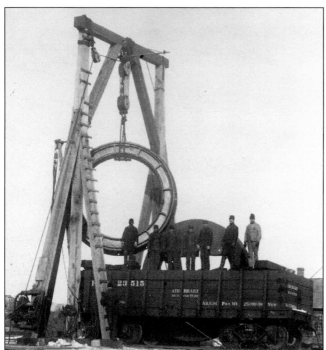

A base ring, mounted in concrete, provided support and mobility for large cannons. This one is being unloaded early in the 20th century. (Collection Gateway, Sandy Hook.)

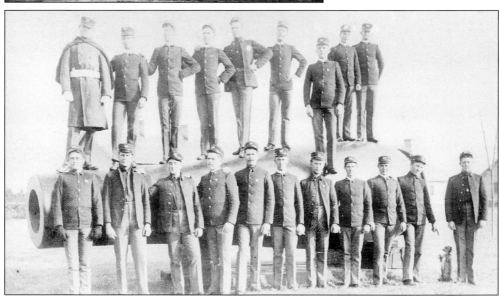

Thomas Jackson Rodman, born 1815, graduated from West Point in 1841. He showed an early aptitude for invention and developed a gun casting that resulted in greater strength and endurance for heavy ordnance. He commanded the Watertown, Massachusetts, arsenal during the Civil War and applied his methods to casting 12-, 15-, and 20-inch smooth-bore guns and 12-inch rifled guns. His guns were also mounted in newly iron-clad naval warships. Rodman commanded the Rock Island, Illinois, arsenal after the war. He was perfecting plans there for a large combined armory and arsenal until he became sick and died in 1871 after a prolonged illness. Today's exhibition Rodman Gun, also seen on p. 121, is shown here on a c. 1910 postcard.

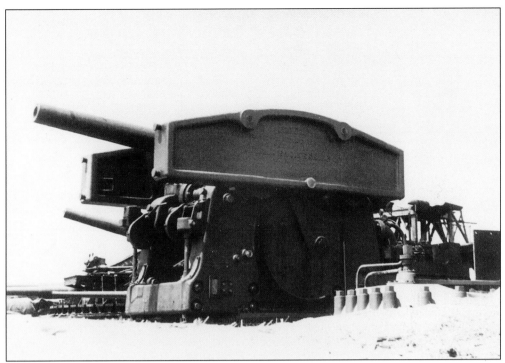

A disappearing carriage of a 10-inch, breech-loading cannon is shown *c.* 1890s, positioned between side counterweights. A dropping counterweight would raise a gun into firing position. The recoil following firing would raise the counterweight, causing the gun to disappear behind its protective wall. (Collection Gateway, Sandy Hook.)

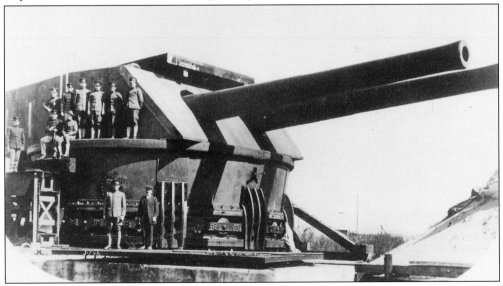

This U.S. Army-designed turret, resembling a naval turret, tested 14-inch guns at Sandy Hook. The guns were shipped to Manila, Philippine Islands, the only facility to employ them, and mounted on concrete platforms in the harbor built to resemble a battleship. The installation, officially designated at Fort Drum, was known in popular parlance as "the concrete battleship." (Collection Gateway, Sandy Hook.)

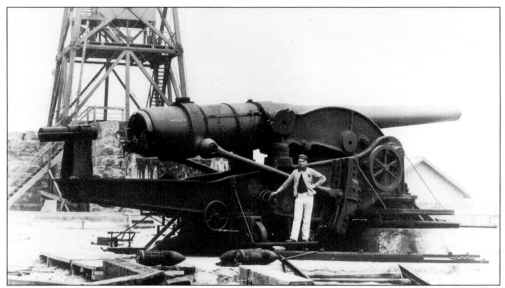

This 10- or 12-inch gun (the small differences are often difficult to discern in photographs) has its counterweight underneath. Typical tests for each gun included velocity, accuracy, rapidity, rapidity with accuracy, dust, firing with excessive charges, and firing with defective cartridges, generally with a common number of rounds for each gun tested. (Collection Gateway, Sandy Hook.)

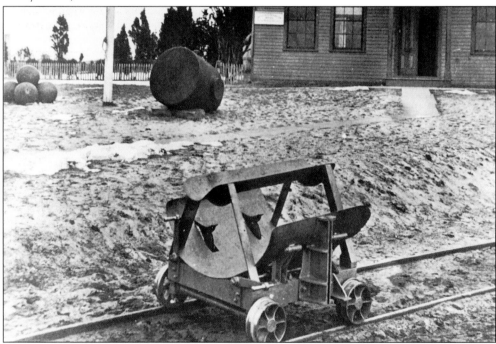

The United States Engineers Office stood west of the present Coast Guard main gate, near its dock. The railway cart, on the narrow gauge line that began at the dock, is of proving ground interest, containing a tray for artillery shells and holders for gunpowder bags. The "barrel" in the background is a Civil War–era 13-inch caliber seacoast mortar. The bore appears to be filled-in; its cannon balls are to the left. (Collection Gateway, Sandy Hook.)

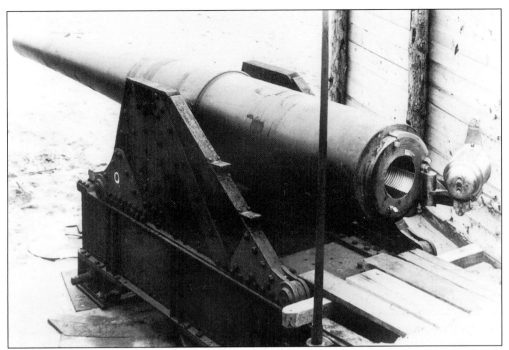

An unidentified, undated example of heavy artillery, probably 8 or 10 inches, is viewed with its breech open. Groupings of guns tested included field artillery of varying weights, lighter mountain artillery carried by mules (when in the field), siege artillery, and heavy coastal defense guns. (Collection Gateway, Sandy Hook.)

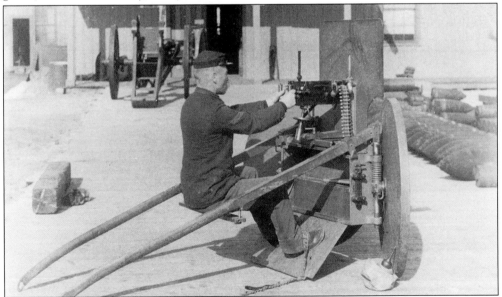

An ordnance sergeant is seated behind a .45 caliber Maxim machine gun c. 1890s. The gun was horse drawn, and the wheels pivoted to form a shield. The sergeant's head gear is a kepi, a French cap that was discontinued in 1892 (but existing examples were likely worn later). This example is of a proving ground personnel; however, the army also kept machine guns at Fort Hancock to repel would-be invading forces. (Collection Gateway, Sandy Hook.)

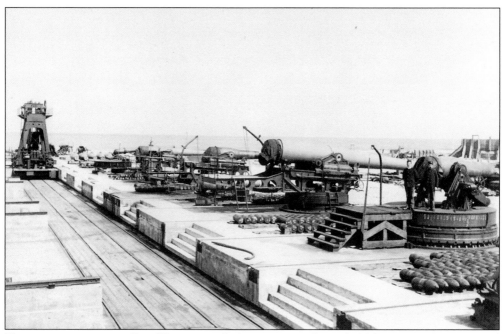

Various guns are seen at Proof Battery, ready for testing, in the early 20th century. Cannons and mortars were tested at the same time. The carriage on which the gun was mounted was of vital importance, as it needed to take up the enormous energy of the firing recoil without impairing the gun or the mounting. A great variety of gun types and energy-absorbing methods were tested. The concrete platform remains in the park. (Collection Gateway, Sandy Hook.)

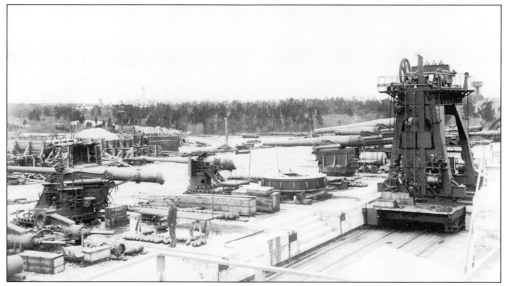

A companion photograph to the one at top, this view, looking south, places Proof Battery in the context of the lighthouse, visible in the background. This new Proof Battery was built 1900–1901 about 300 yards to the south of the original, to provide both separation from Fort Hancock and a better firing range. Another major improvement was the installation of this sizable gantry crane, which reduced the time required to place a 52-ton, 12-inch gun barrel on a flat car from four hours to under an hour. (Collection Gateway, Sandy Hook.)

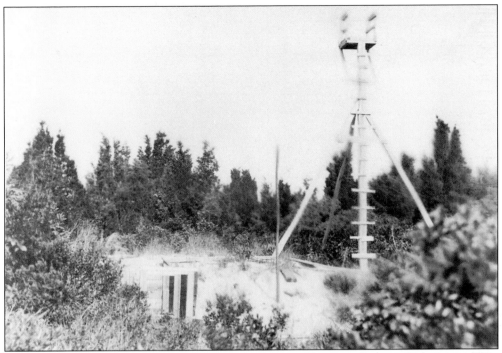

This wood observation platform is believed to have stood between Battery Gunnison and the present visitors' center. Long-range firing over the water was measured by plane tables, with a point at the proving grounds and a second at Twin Lights. This gave a base line measuring a little over 5 miles. The point of a shell's splash was the apex of a triangle, with its distance determined by trigonomic principles. This picture is a *c.* 1880s view. (Collection Gateway, Sandy Hook.)

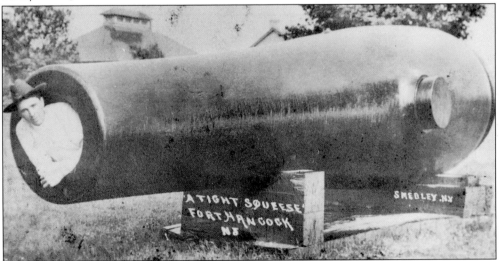

The Rodman Gun was the largest bore weapon in the American arsenal, evidenced by the man's perch, "tight squeeze" notwithstanding. The gun is capped today, more to avoid its serving as a trash receptacle than to preclude photo opportunities. On this *c.* 1912 photographic postcard, note the blocks on which the gun rested prior to the 1937 construction of the present base (see p. 121) by the Civilian Conservation Corps. (Collection of John Rhody.)

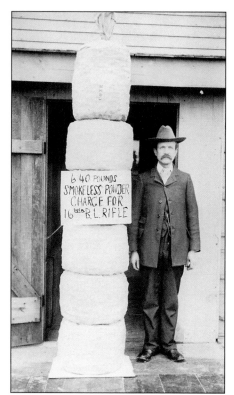
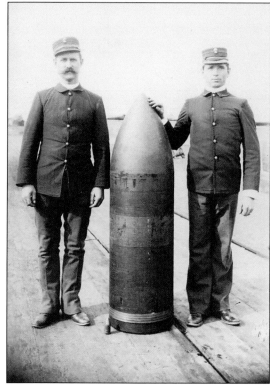

The 16-inch projectile was usually over 2,000 pounds; the small shell to the left of it was likely a one-inch, or sub-caliber, round. Although this powder charge was specified at 640 pounds, varying weights were used to stress-test guns. Higher weights could provide additional power but could increase the possibility of a gun's cracking. (Collection Gateway, Sandy Hook.)

The surroundings of this brick ammunition magazine, Building 38 on old proving ground maps, are interesting. Note the empty ammunition crates, the observation tower, and the Proof Battery catwalk. The building was demolished after World War II, but its concrete slab remains. It is located north of the extant Proof Battery. (Collection Gateway, Sandy Hook.)

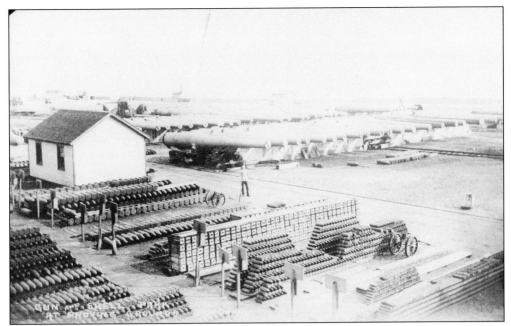

This broad perspective, c. 1902 view of Gun Park, the gun, and the shell storage area, suggests the scope of proof operation. During busy test periods, the cacophony of firing cannons would be day-long. Windows were kept open to prevent their breakage. The guns were stacked by size, with 8-, 10- and 12-inch guns being the core of the army's arsenal. Outdoor storage of shells was likely brief and they were cleaned before firing.

Building 132 was erected in 1907 for proving ground storage of equipment and ordnance supplies that required an indoor environment. It later served various other functions, including as the Fort Hancock motor pool and paint shop. The still-recognizable building stands in the North Maintenance area, near the Coast Guard gate. (Collection Gateway, Sandy Hook.)

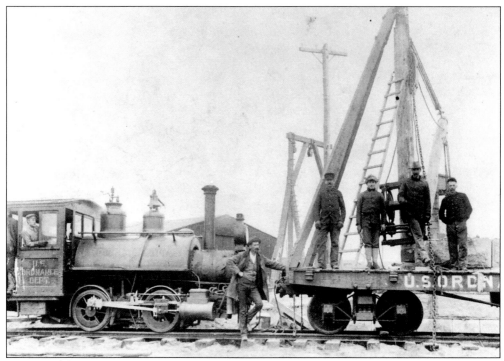

The proving ground had a complete railway system that connected to the Central Railroad of New Jersey tracks, tracks at their dock, and branch lines to the Proof Battery. This smaller "donkey" switching engine was used for yardwork. The crane on the flatcar hoisted heavy loads. Behind it is the old fort at Sandy Hook. (Collection Gateway, Sandy Hook.)

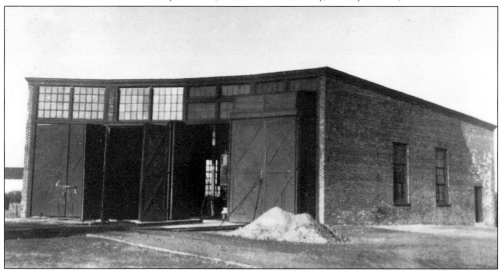

The proving ground storehouse, Building 135, was completed at the north end in 1905 to provided indoor storage of locomotives. It was demolished in the post-World War II period. Trains from the proving ground tested the capacity of the railroad system. A shipment in 1895 of a 12-inch gun to San Francisco was said to have been the heaviest transcontinental load ever, requiring a special car with a 175,000-pound capacity. The then-usual load limit was 40,000–50,000 pounds per car. (Collection Gateway, Sandy Hook.)

The red brick, T-shaped Building 102 was erected in 1909 as an enlisted men's barracks for proving ground personnel. It was later used for Fort Hancock soldiers and by the Coast Guard in the 1970s. The substantial structure at the north end facing Sandy Hook Bay has changed little, but the porch is now partially enclosed. There was a masonry color distinction when the fort and proving ground co-existed; they were buff and red respectively. (Collection Gateway, Sandy Hook.)

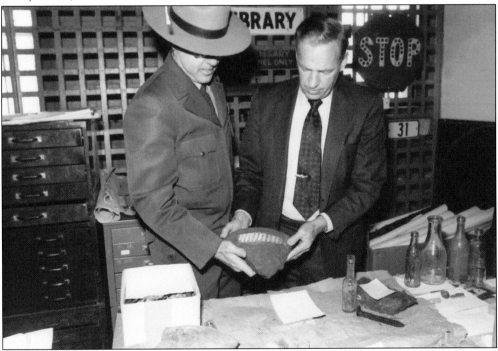

Unexploded proving ground ordnance buried in the beach was uncovered over the years. The issue turned into a crisis in 1979, resulting in the closing of the park in mid-November. Congressman James J. Howard is seen in the museum with Kenneth O. Morgan, superintendent of Sandy Hook Unit, inspecting a large fragment of a 10- or 12-inch shell. The grooves were made by the rifled barrel of the gun. The park reopened May 1, 1980.

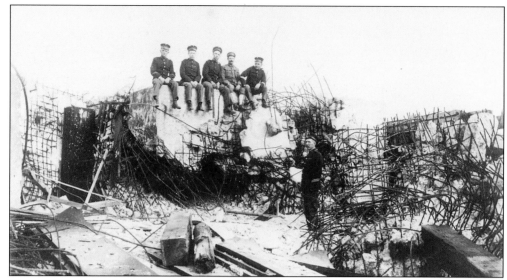

The testing of the destructive power of projectiles and the effectiveness of a wide variety of gunpowders were as important as testing guns. The 3.7-mile firing range at Sandy Hook, which was less than ideal, had targets erected at various points for different tests. These soldiers were posing in 1912 on a reinforced concrete target. Firing tests longer than the land range were made over the ocean. (Collection Gateway, Sandy Hook.)

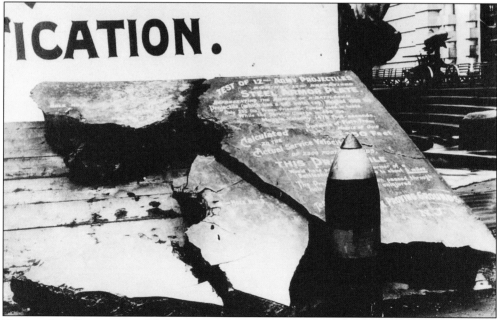

Testing the effectiveness of defensive armor was also crucial, especially in a nation without hostile intent. Targets were constructed of the best and strongest of costly steel plate. This 12-inch Harveyized-steel armor-plated target was pierced by this 12-inch shell. The condition of the projectile after penetration was another important criterion of the test; this 1,000-pound projectile passed through unmarred. There were three basic families of ammunition in the Sandy Hook period—solid shot, shells for carrying high explosives, and shrapnel. (Collection Gateway, Sandy Hook.)

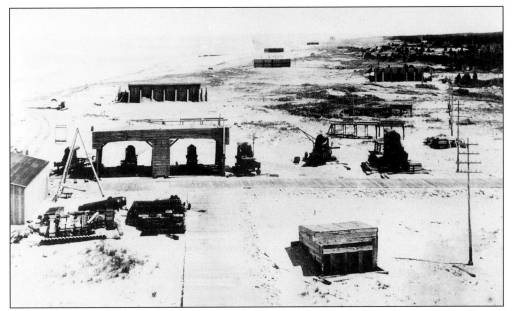

This early 1880s view from Proof Battery shows several targets along the range, the first at point-blank distance. The charge of powder in close-up targeting was varied so as to make the projectile strike the target with the same energy that it would if hitting a more distant target with a full powder charge. Velocity screens (frame structures containing strung wire) also lined the firing range. (Collection Gateway, Sandy Hook.)

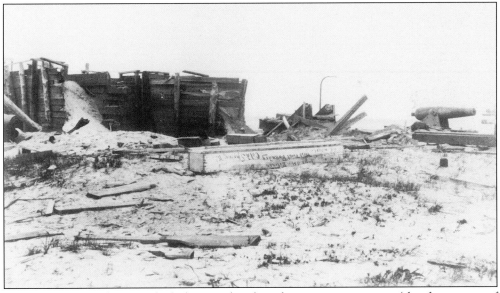

An exploded gun has wrecked the wood-and-sand protective traverse (the forerunner of concrete structures) at left in this early 1880s photograph. The gun at right may be a rare Rodman experimental conversion to breech loading; the exploded gun is not identified, but may be a companion Rodman. Three Rodman rifling conversions exploded. The variables in experiments, including types and charges of powder, the energy produced, and wear on a cannon and its parts, created the potential of danger in most tests. (Collection Gateway, Sandy Hook.)

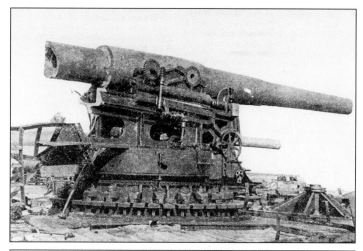

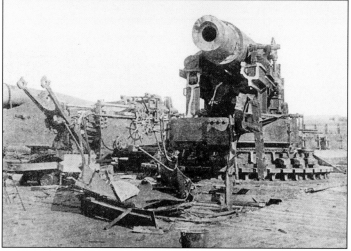

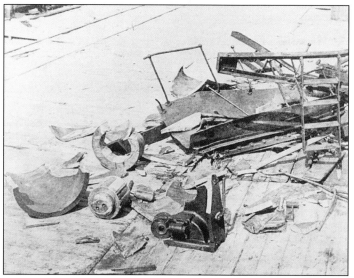

A 10-inch gun exploded in March 1899, killing Henry M. Murphy of Atlantic Highlands and wounding a Private Demar and an employee named Harrington. The gun had been tested successfully earlier in the month. The explosion blew out the breech block, sending it through a protective traverse (a 12-foot-thick barricade of sand and timber located 50 feet from the gun); the block struck Murphy and cut him in two. The 1,000-pound piece landed in a repair shop 200 yards in the rear. Stronger traverses were later built of concrete. The explosion was believed to have been caused by excessive pressure created by the gunpowder. Its force was estimated at 75,000 pounds per square inch at the time of the accident, but was later believed to have been in the 100,000-pound range. This was the first explosion of this type of weapon, a 22-foot-long, breech-loading rifle weighing 100,000 pounds. The pictures of the side view, breech end, and fragments were published in the August 12, 1899 *The Mail and Express Illustrated Saturday Magazine*.

Four

COASTAL DEFENSE

A major coastal defense facility at Sandy Hook was conceived in the 1850s; a granite-walled fort was begun in 1859 but was never completed. This c. 1900 picture shows the non-commissioned officers of the 48th Coast Artillery Regiment in front of Building 23. Commanding the lens (front row, center) became a regular posture for First Sergeant Tom Mix, who later had a distinguished stage career after a dubious military one. He joined the U.S. Army in 1898, came to Fort Hancock in 1901, and deserted the following year. (Collection Gateway, Sandy Hook.)

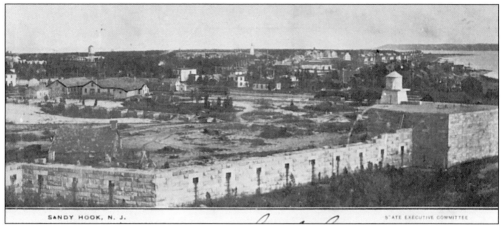

This 1904 postcard provides a close view of the Civil War-era fort, including its southwest bastion, or corner (the large block at right). The water tower over it was replaced in 1910. The light, two-story structure left of the lighthouse was the oldest standing frame building when it was destroyed by fire in December 1991. Note the foundation for the south wall in front of the shops at left. Some stones from this fort were used for other construction, but much of it was used in beach erosion prevention projects, including early sea walls.

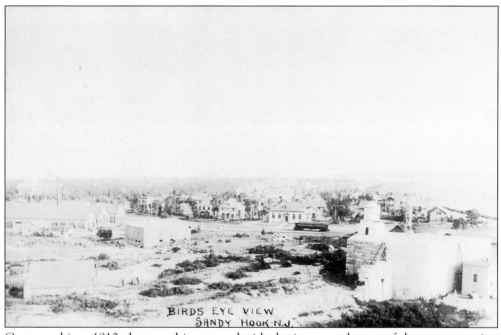

Compare this c. 1910 photographic postcard with the image at the top of the page to review intervening construction. The c. 1907 red brick proving ground utility buildings are at left; one is also on p. 77. The 1905 railroad storehouse is to their right and can be seen on p. 78. The unidentified building in the lower left corner, presumably storage, is no longer extant; the storage building at far right still stands, but in derelict condition. The radio tower was built in 1908. The water tower at right was replaced by the one on p. 53. Notice, too, the removal of most of the wall in the foreground. (Collection of Harold Solomon.)

Dynamite Gun Battery, also known as Pneumatic Gun Battery, was among the earliest of the coastal defense gun installations built in the open on the present Coast Guard grounds. The inadequate sandbag covering was later replaced by concrete walls. Dynamite guns were so-called as their shells were filled with dynamite. They were fired, however, by compressed air. The stacks to the right of the guns were part of the compressed air works that provided their propellant. This Charles R.D. Foxwell photograph is from c. 1895. (Collection of Richard C. Winters.)

Five unidentified members of the 55th Coast Artillery Regiment are seen c. 1900 in an enigmatic pose with two rabbits, which gives rise to the question, "are they pets or dinner?" The men look sheepish; the author tends to think "dinner." One observer commented that the rabbits seem small, so maybe they were lunch.

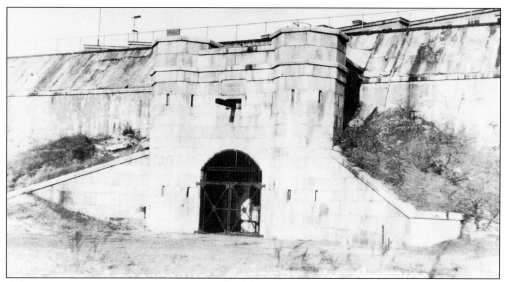

A battery is one or more cannon, generally the same caliber, commanded directly by a single individual and firing at the same target. The battery includes structures, equipment, and personnel necessary for emplacement, protection, and service. Construction of Lift Gun Battery Number 1 was begun in 1891, while masonry work was completed in 1893. Guns were raised and lowered by elevators; north and south guns were first fired in 1892 and 1895 respectively. This image is a c. 1907 photographic postcard. (Collection of John Rhody.)

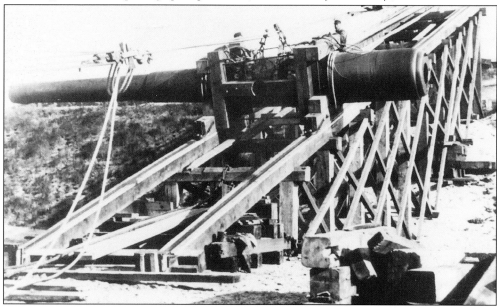

Lift Gun Battery Number 1 was renamed Battery Potter in 1900, in honor of Civil War Brigadier General Joseph Potter. Its armament was two Model 1888 12-inch guns mounted on French-manufactured barbette carriages. One is seen being skidded in 1895. The guns were soon made obsolete by faster-firing, counterweight-operated guns developed at the adjacent proving ground (see p. 71), so Potter was the only steam-powered disappearing gun battery built in the United States. The still-standing but crumbling battery is open for escorted tours from time to time. (Collection Gateway, Sandy Hook.)

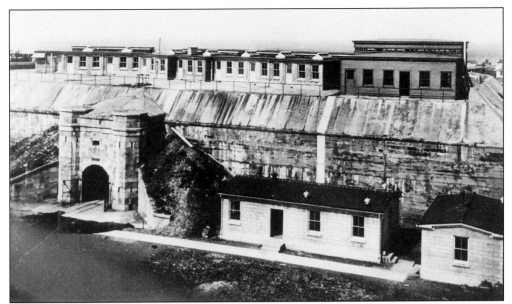

Battery Potter was disarmed in 1906 and its elevators and guns were removed. Its roof was used as a fire-control station for nearby batteries. The frame building at right was built in 1905, while the larger adjacent concrete structure was built in 1907, following removal of elevators and guns. The World War II Advanced Harbor Entrance Control Post, which monitored all harbor ship movements, was later located here. (Collection Gateway, Sandy Hook.)

A range-finding crew is posed outside Battery Potter in this World War I–era view. The two officers in the center may be identified by their hats and high leather boots. Potter was a fire control station for Batteries Peck, Alexander, Halleck, Bloomfield, Richardson, and Gunnison, as well as the two mortar batteries. (Collection Gateway, Sandy Hook.)

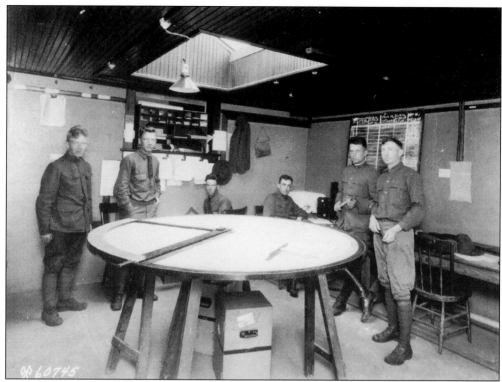

A plotting room on the roof of Battery Potter is seen in this 1919 photograph. The room behind the wall at left faced the ocean and housed a spotter with a telescope. Note the slide rule held by the soldier second from the right. (Collection Gateway, Sandy Hook.)

This secondary sighting station was utilized in conjunction with Battery Potter. If Potter had been lost, this station would have become primary. Notice the opening at left, a long viewing slit on the side facing the ocean. The photograph was taken c. 1910; the building was demolished at an unknown date. (Collection Gateway, Sandy Hook.)

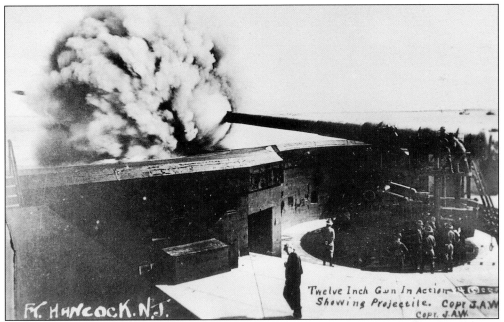

Twelve Inch Gun In Action
Showing Projectile. Copr J.A.W
Copr. J.A.W

FT. HANCOCK. N.J.

A projectile is seen at the moment of discharge from a 12-inch gun on a disappearing counterweight carriage. The gun is similar to those at Fort Hancock, but the picture was likely taken elsewhere. The "Fort Hancock" designation in the lower left corner was added as a convenience to marketing the c. 1915 postcard locally. Adding the local name to generic pictures was once a common practice. Even Fort Hancock postmarks do not guarantee a card's local provenance. (Collection of Harold Solomon.)

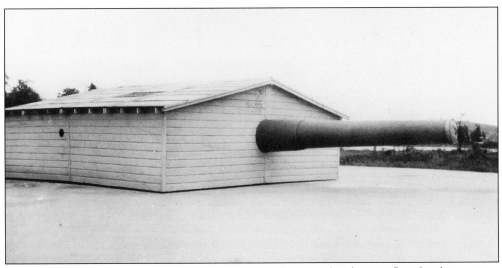

This 1921 photograph at Battery Mills shows an early example of camouflage by the erection of an enclosure around a gun; it appears to be an insignificant structure. (Collection Gateway, Sandy Hook.)

89

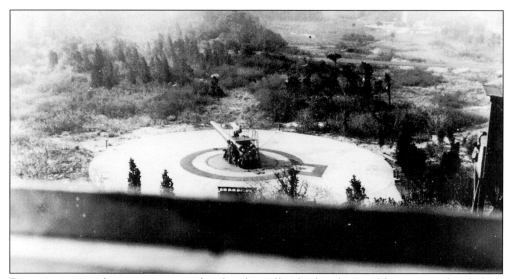

Disappearing gun batteries were rendered technically obsolete by World War I–era battleships that could employ long range, high-angle gun fire to hit gun emplacements within the battery while staying out of range of the shore guns. The Army Ordnance Department developed a high-angle barbette carriage that allowed their 12-inch guns to fire farther than the battleship guns. Sitting on circular platforms out in the open, the guns had a 360-degree field of fire for 20 miles in any direction. Battery Kingman was built in 1917–18 and named for Brig. Gen. Dan C. Kingman, a chief of army engineers. (Collection Gateway, Sandy Hook.)

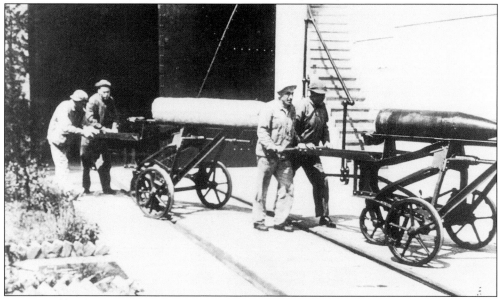

Battery Mills, also built 1917–18, was named for Brig. Gen. Albert L. Mills, who was awarded the Medal of Honor for his actions in the Spanish-American War. The two batteries were located near Horseshoe Cove on Sandy Hook Bay, their guns screened from view by the nearby holly and cedar forests. They were similar in appearance, making them difficult to distinguish in photographs such as this one. In this view, soldiers push ammunition carts from a battery's magazine. A 12-inch shell is in front, while the rear cart contains a gunpowder bag with a charge of about 270 pounds. (Collection Gateway, Sandy Hook.)

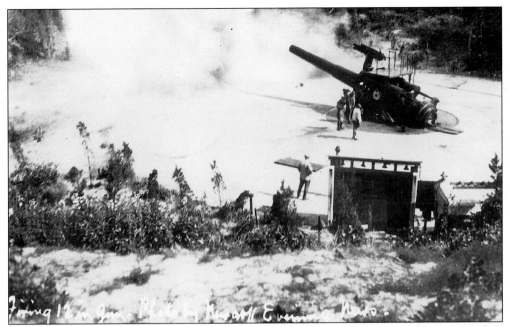

Annual target practice at either Kingman or Mills is seen on a 1920s photographic postcard. A rangeboard is in front, worked by a soldier with a headset. He receives telephoned instructions from a rangefinder, including elevation, powder charge, and movement of the gun, and then marks them on the board for the gunners.

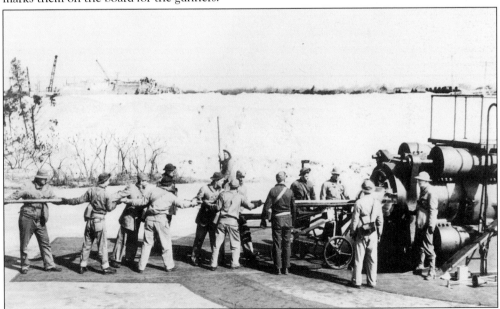

Soldiers are loading a 12-inch barbette gun at Battery Mills, with the construction of Battery Kingman's casemate visible in the distance. The two batteries were modified in 1941–42 by the construction of casemates, concrete rooms with walls and roofs 10- and 17-feet thick respectively, covered by earth and sand. The two batteries were Fort Hancock's most formidable defenses during World War II, but would have still been vulnerable to massed bombing or a blockbuster bomb. (Collection Gateway, Sandy Hook.)

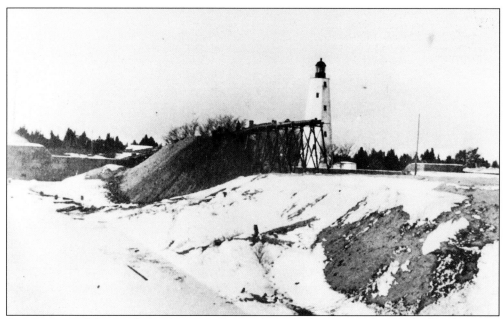

Construction of the Sandy Hook Mortar Battery began in late 1890, close to the lighthouse, as evidenced by this photograph taken early during the construction. The destructive principle of these mortars was to fire 700-pound, armor-piercing shells in a high trajectory that would pierce the lightly protected deck of an enemy ship. A 1,049-pound projectile was used for targets in close range. (Collection Gateway, Sandy Hook.)

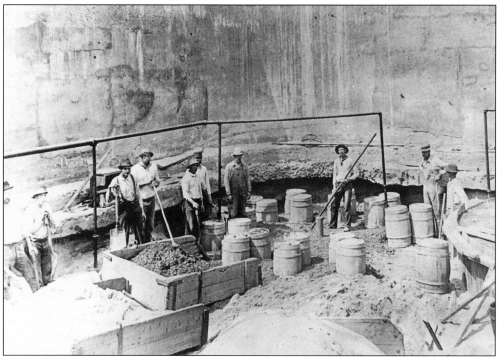

Workers in July 1893 are seen excavating for the foundation of the mortar carriages. (Collection Gateway, Sandy Hook.)

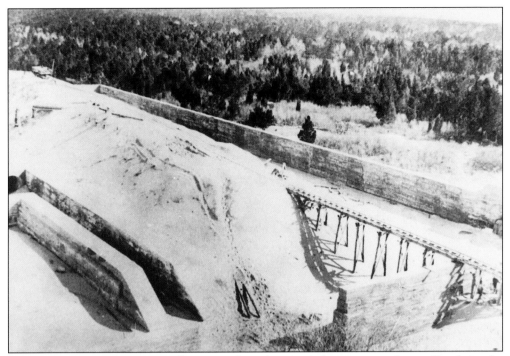

A counterscarp, or exterior wall, surrounding the entire battery runs diagonally along the middle of this c. 1893 picture. The opening at left is an alleyway into a mortar pit. (Collection Gateway, Sandy Hook.)

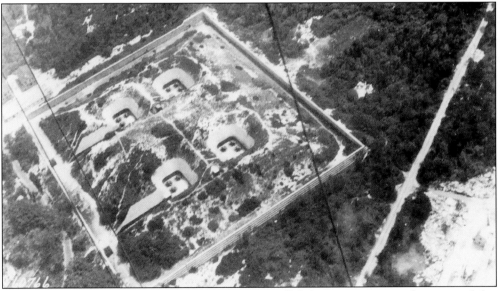

A c. 1919 aerial shot from a balloon flight shows all four pits, suggesting their massed fire principle. Finding that it was difficult for a battery commander to coordinate the firing of 16 mortars, the army separated the pits into two firing commands. The two pits at top, closer to the beach, were designated as Battery McCook (named for Major Gen. Alexander McCook, a Civil War veteran). The two rear pits were named Battery Reynolds for Major General John F. Reynolds, who was killed at the Battle of Gettysburg. (Collection Gateway, Sandy Hook.)

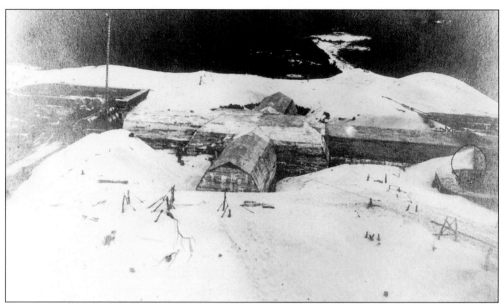

The cross-shaped structure in the center of this *c.* 1892 photograph is a traverse, a concrete tunnel that connected the four batteries and permitted the storage and transport of ammunition. These traverses were later buried in sand. World War I–era battleships, which could fire well outside the shorter range of the mortars, made them obsolete. The mortars at Sandy Hook were removed shortly after that war. (Collection Gateway, Sandy Hook.)

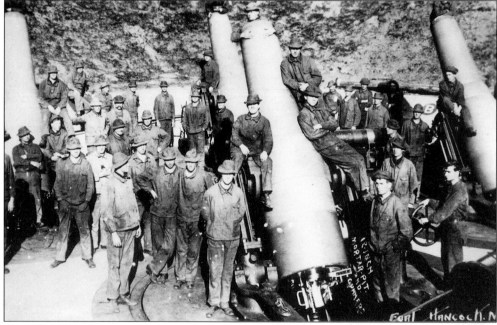

Four 12-inch rifled mortars, each with a prospective human projectile, are seen in a mortar pit. Despite the designation in the lower right corner of this *c.* 1915 postcard, these guns, although similar to Fort Hancock's, were probably not located there. A companion picture shows a high level of the earthwork walls, while Fort Hancock's pits are concrete. A collector with a mis-labeled card is liable to grumble, "This is the pits." (Collection of Harold Solomon.)

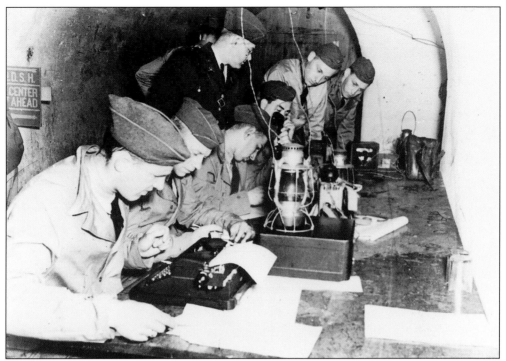

The heavily protected tunnels, regarded as bombproof, served in World War II as the site of the U.S. Army's Harbor Defense Command, which coordinated coastal defense activities from the area of Bay Shore, NY, to Atlantic City, NJ. A telegraph message receiving station is seen here *c.* 1942. The lantern illumination simulated wartime conditions. Two of the four mortar pits are open today to self-guided tours, while the two others are overgrown with vegetation. (Collection Gateway, Sandy Hook.)

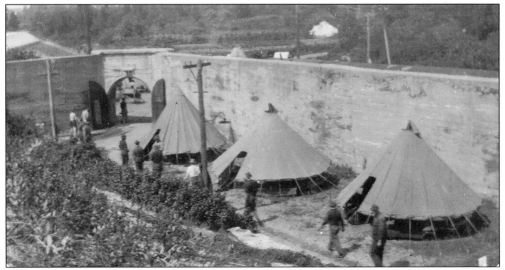

The north wall of the mortar batteries, later demolished, is shown along the middle of this rare *c.* 1910 photograph, together with the original entrance. The tents likely belong to soldiers on summer target practice duty. The hill is now heavily overgrown. Barracks were built during World War II, in the area on the left in the background.

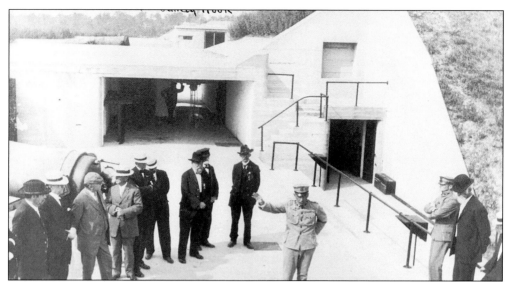

A three-gun battery at Horseshoe Cove was completed in 1908, following the 1906 disarming of Battery Potter, which was built to defend the Sandy Hook Bay and Shrewsbury River side of Fort Hancock in the event that enemy ships got past ocean-facing guns. The battery, armed in 1909 with Model 1888 8-inch guns and mounted on Model 1894 counterweight carriages, was named Arrowsmith in honor of Monmouthite Lt. Col. George Arrowsmith, who was killed at the Battle of Gettysburg. Battery Arrowsmith was made obsolete by Batteries Kingman and Mills, which both had a 360-degree firing capability (until casemated) and a longer range.

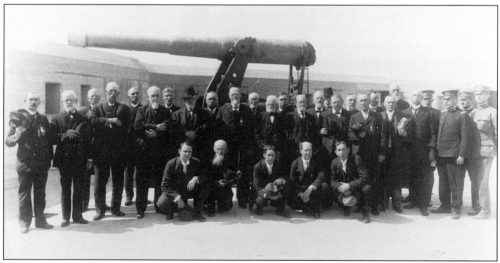

Battery Arrowsmith was dedicated on May 25, 1909. A delegation from Arrowsmith Post Number 61 of the Grand Army of the Republic, Red Bank, attended, along with invited guests. Their members made a request for the naming to Secretary of War (and future President) William Howard Taft. Members also witnessed a firing and were allowed to roam the fort at will. The battery's guns were removed in the late 1920s. Beach erosion undermined the battery's front wall, creating extremely hazardous conditions, which did not deter sightseers. The concrete walls were broken-up in the 1990s to prevent trespassers from entering. Both pictures were taken on dedication day.

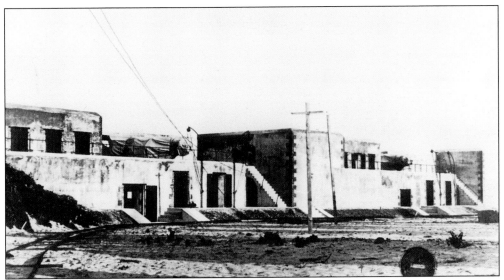

Ten Inch Gun Battery Number 1 was begun in 1896 and armed in 1898 with two Model 1888 10-inch guns mounted on Model 1896 counterweight carriages. It was named for Major Gen. Gordon Granger (1822–1876), who commanded the Union Army of Kentucky in the Civil War. The section at left was extended *c.* 1907 as the platform was too short for the gunners' work. Note the quoins to the right of the center stairs; this is a decorative feature not often repeated at the fort. (Collection Gateway, Sandy Hook.)

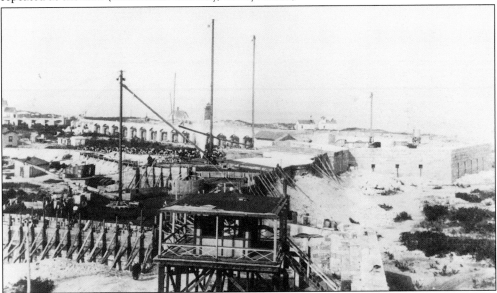

Battery Halleck, begun in 1897 and completed the next year, was earlier called Ten Inch Battery Number 2. It was armed with three Model 1888 10-inch guns mounted on Model 1896 counterweight carriages and was renamed for Gen. Henry Wager Halleck (1815–1872), who held numerous Civil War positions, including a period as general-in-chief at the U.S. Army headquarters. Battery Halleck became the first of the massed batteries, then and still called Nine Gun Battery. Prior to completion of the last two of the nine guns, the Halleck name embraced the seven guns later divided into separate commands. (Collection Gateway, Sandy Hook.)

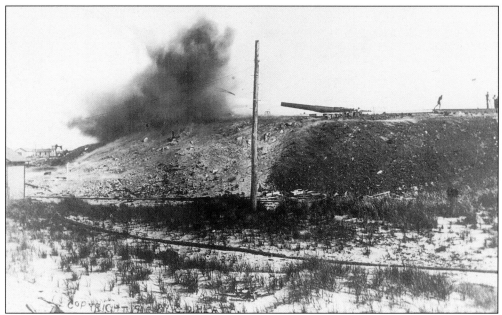

A disappearing gun, believed to be a 12-inch counterweight, is seen at the moment of fire at Battery Alexander c. 1910, the northernmost part of Nine Gun Battery. Although batteries were generally spaced apart in most coastal forts, they were massed at Fort Hancock; the terrain and the prospective targets—ships in the channel, well within the 8-to-9-mile range of their guns—favored such placement. The gun in this picture is actually firing north. (Collection Gateway, Sandy Hook.)

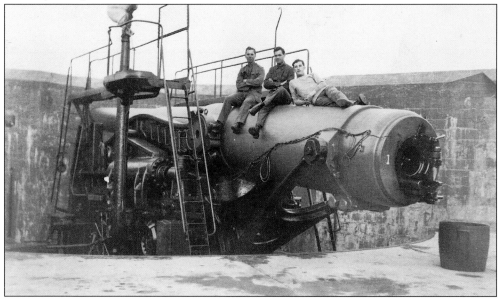

A c. 1910 photographic postcard of soldiers at ease in an unidentified battery, perhaps Richardson, provides helpful operational glimpses. The gun is in loading position; the counterweights will raise it over the wall during firing. The barrel is likely a sponge bucket, as a sponge on the rammer would be used to remove powder residue from the breech. A telescopic sight on the tower is covered by a protective hood. (Collection of Michael Steinhorn.)

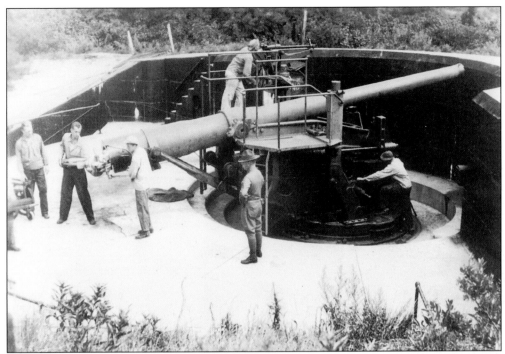

Battery Gunnison was completed in 1904; it was planned as a rapid fire battery that could command the southern shoreline and eastern ocean approaches to the harbor. Built over one-half mile south of Nine Gun Battery, it was named to honor Capt. John W. Gunnison, who was killed in action in 1853 in Utah Territory. Gunnison was armed in 1905 with two Model 1903 6-inch guns mounted on Model 1903 counterweight disappearing carriages. (Collection Gateway, Sandy Hook.)

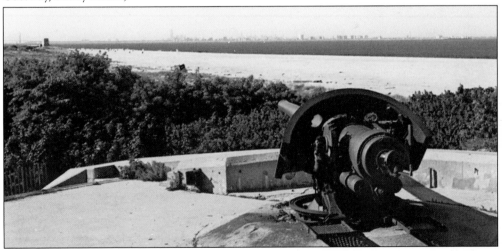

Battery Gunnison was modified in 1943 with the installation of the two 6-inch guns and barbette carriages from Battery Peck; the new weapons were intended as the primary defense against motor torpedo boats. The battery was re-designated Battery New Peck. This 1976 photograph (published as a postcard) by Al Zwiazek, who served with C Battery of the 52nd Coast Artillery Regiment from 1937 to 1939, conveys the command over the harbor from the southern beach. New York is visible in the background.

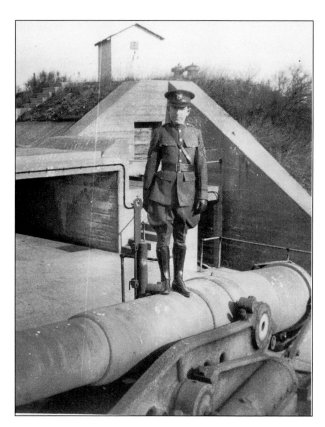

ROTC Staff Sgt. John Joseph Mulhern is seen atop a gun barrel c. 1925 at Battery Arrowsmith. He was raised at Sandy Hook; his father was employed at the water pumping station. John had a detailed memory of his life there in the years prior to his 1927 graduation from Rutgers, the same year his father left employment at the Hook. He shared those memories generously with the park staff. John was a skilled photographer, knowledgeable in many disciplines, and was an all-around nice person. He died in 1996 at the age of 91. (Collection Gateway, Sandy Hook.)

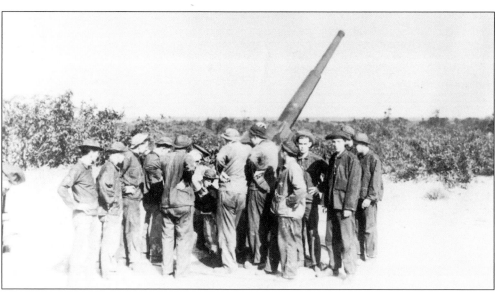

The army installed three 3-inch caliber anti-aircraft guns on the dunes, about 100 feet southeast of the Spermaceti Cove Life Saving Station that is now the visitors' center. Seen here c. 1937, the guns were bolted on concrete bases; fire control was directed from Battery Potter and nearby spotters. Height finders were located on the sides of the guns. (Collection Gateway, Sandy Hook.)

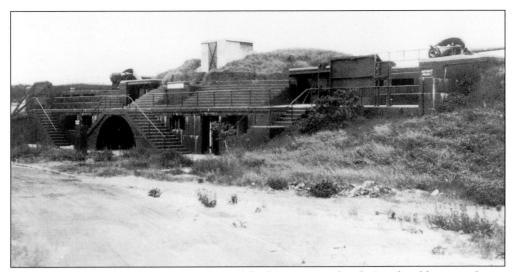

Battery Peck, completed in 1903, was a rapid-fire battery armed with 6-inch caliber guns. It was named for Lt. Fremont P. Peck, who was killed in an 1895 gun-testing accident at the proving ground. This c. 1921 photograph shows Peck's two Model 1900 6-inch guns mounted on Model 1900 barbette carriages. These guns were transferred to Battery Gunnison (see p. 99) in 1943, when two 90-millimeter guns were installed and Peck was renamed Battery Number 8 as part of the numbering system for New York Harbor Defense Sector for 90-millimeter gun batteries. (Collection Gateway, Sandy Hook.)

A searchlight and communications hut are seen in this undated photograph. The structure also sheltered the light, which was on tracks and left the building via large doors on the side (not visible here). Prototypes were also mounted on high towers. (Collection Gateway, Sandy Hook.)

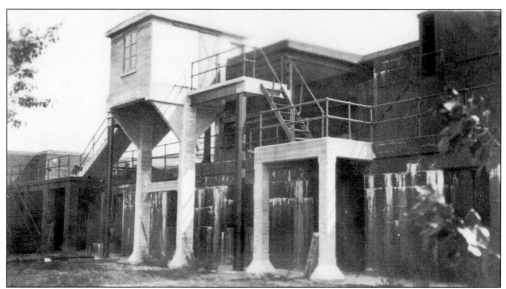

Twelve Inch Gun Battery Number 4 was completed in 1902 and armed in 1904 with two Model 1900 12-inch guns, mounted on Model 1900 counterweight carriages. It was later named for Major Gen. Israel Bush Richardson, who was born in 1815 and graduated from West Point in 1841. He was mortally wounded in 1862 at the Battle of Antietam. Richardson was the southernmost of Nine Gun Battery; it consisted of one long, concrete wall at the northern tip of Sandy Hook. (Collection Gateway, Sandy Hook.)

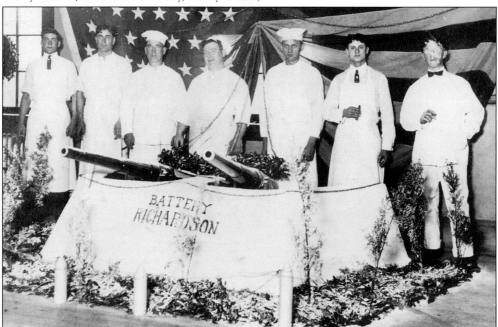

The kitchen staff is seen with decorations at an undated Christmas banquet. What could those gun barrels have been made of? The author would like to imagine chocolate, or even better, marzipan. Nine Gun was separated into four separate commands due to the difficulty of a single commander coordinating nine guns. The others were Alexander, Halleck, and Bloomfield. (Collection Gateway, Sandy Hook.)

The cooks at the 48th Coast Artillery are seen in camp in 1909. Students of uniforms may wish to examine the shirts, garments often covered by other articles of military garb. This image is a Smedley photographic postcard. (Collection of John Rhody.)

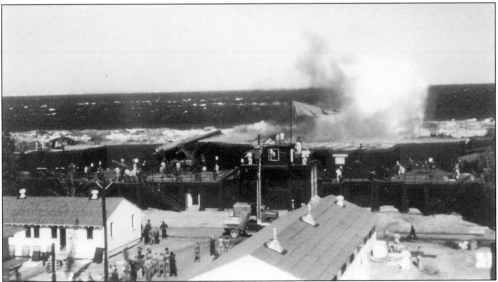

Twelve Inch Gun Battery Number 3 was built in 1898 south of Alexander and armed in 1899 with two Model 1888 12-inch guns mounted on Model 1896 counterweight carriages. This part of Nine Gun Battery was named for Joseph Bloomfield in 1904, when Nine Gun was divided into four commands. Bloomfield was governor of New Jersey in 1801 and from 1805 to 1812. A Revolutionary War veteran, he was appointed a brigadier general by President Madison in 1812. The picture is a practice firing c. 1941. (Collection Gateway, Sandy Hook.)

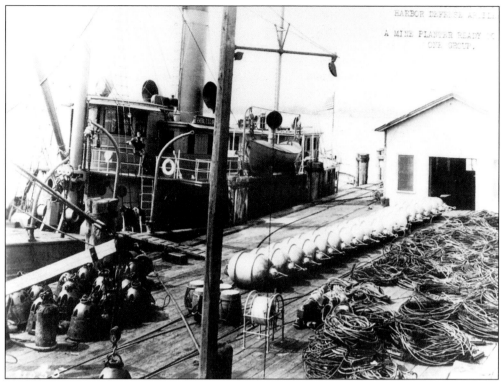

The U.S. Army's mine planter boat *General E.O.C. Ord* is seen *c.* 1930, ready to take in a load of underwater mines. Notice the coils of cable. The army's mines were the "controlled" variety, which were detonated by activating a control from land, typically an electronic charge through the operation of a knife switch. (Collection Gateway, Sandy Hook.)

Building 509, now on Coast Guard property, is shown early in the 20th century, when it was used for the storage of army underwater mines. Mines were first used in the harbor *c.* 1890s. The building was later a warehouse; in the early 1990s, it housed two National Park Service horses, prior to their relocation to the stable (see p. 37). (Collection Gateway, Sandy Hook.)

The mine casemate is seen under construction *c.* 1921, using part of the concrete walls of the Dynamite Battery, which was abandoned *c.* 1900. The new casemate would have larger rooms and its own tower for observation and control. A test switch could detect the presence of a mine at the end of a line, but some tests required explosions in the harbor. Those tests were hard on marine life, much to the dismay of fishermen. However, some locals were pleased to change their culinary practice to accommodate the sudden abundance of fresh fish. (Collection Gateway, Sandy Hook.)

The terrain and the formerly narrow dirt road at the "Y," probably the one near Horseshoe Cove, are seen *c.* 1910 on a photographic postcard. The Halyburton Monument is north of the divide in the road. (Collection of John Rhody.)

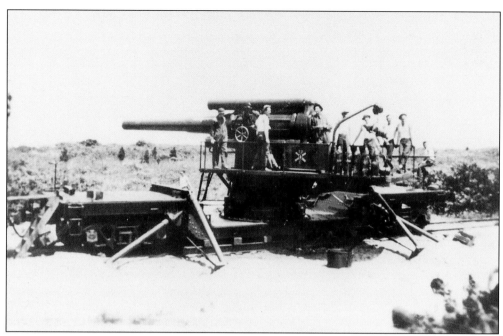

Members of the 52nd Coast Artillery Regiment are seen c. 1938, somewhere on the middle of the Hook, engaging in target practice. Notice the 8-inch shell in the ammunition loading hoist. The gun could be fired in a horizontal position for nearer targets, but was probably so-positioned for loading. (Collection Gateway, Sandy Hook.)

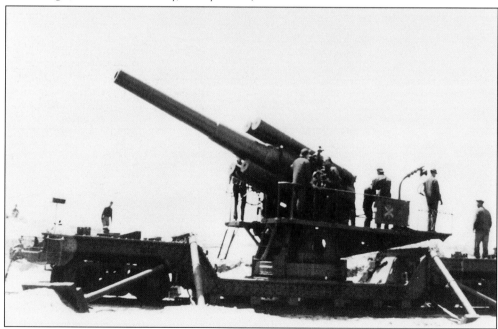

Members of Battery E of the 52nd Coast Artillery Regiment are firing with a raised barrel, a position that increases range. Some individuals in this 1936 photograph are Civilian Conservation Corps members, who were known to have had labor duties at fort military activities. (Collection Gateway, Sandy Hook.)

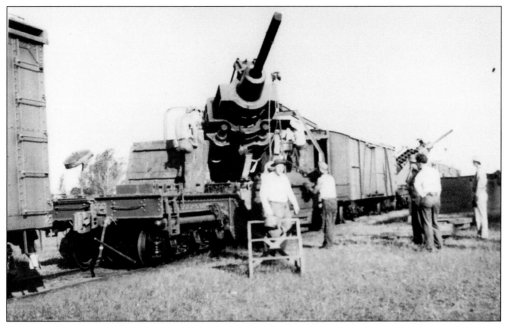

Battery C of the 52nd Coast Artillery Regiment employed 12-inch mortars. Their gun is seen *c.* 1936 with the remainder of their train. An ammunition car was behind the cannon, typically followed by either communications or a food service car. The timber placed halfway out the gun was used for stringing cable for various lifting and utility functions. (Collection Gateway, Sandy Hook.)

The 52nd Coast Artillery made a training expedition in May 1938 to Lewes, Delaware, sending their guns and ammunition by rail across New Jersey and through Philadelphia. Al Zwiazek recalled recently making a camp in an open field near a fish processing plant (left background) and building a 1,500-foot railroad spur to reach the spot. The two guns of Company C became inoperable, each having sheared two of their four mounting bolts after firing. The troops lived in these tents. At the exercise's end, they removed all traces of the camp prior to returning to Fort Hancock.

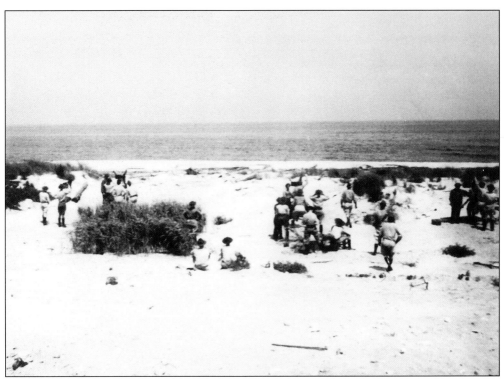

Army coastal artillery soldiers are practicing anti-aircraft gunnery by firing machine guns at a sleeve or streamer carried by a towing plane. Counting the holes—in the streamer, not the plane—would help ascertain the shooter's score. (Collection Gateway, Sandy Hook.)

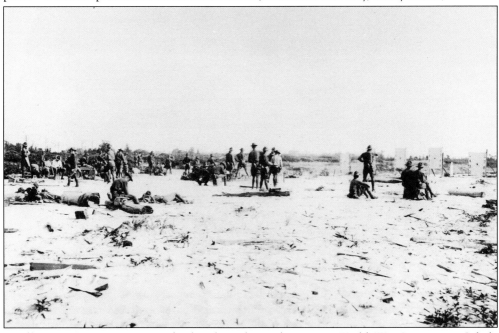

Small arms target practice on the beach is shown here in a World War I–era view. Likely weapons included .30 caliber rifles and .45 caliber pistols. (Collection Gateway, Sandy Hook.)

A gun crew of Battery B of the
245th Coast Artillery Regiment
is seen in 1941 with a .50 caliber
water-cooled machine gun.
Following our entrance into
World War II, some of these
weapons were replaced with
better guns, as were the World
War I–era helmets. (Collection
Gateway, Sandy Hook.)

Lt. John Sweeney is instructing trainees in the use of a range finder c. 1940. The instrument,
used for anti-aircraft defense, aligned two images, one from each end of the tube. Dials gave the
range to a target and the angle above horizontal. (Collection Gateway, Sandy Hook.)

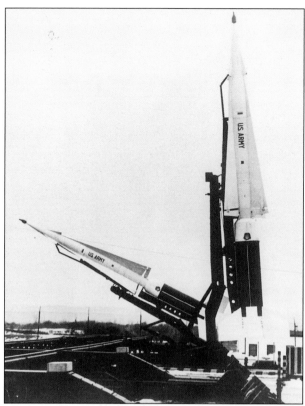

Post-World War II Fort Hancock defenses included the installation of NIKE anti-aircraft missiles, the fort being one of a network of such bases in the metropolitan New York area. Several were located in Monmouth County, with the entire network controlled by the Missile Master command and control center, located at the Highlands Army Air Defense base in the nearby hills of Middletown Township. Two NIKE Hercules missiles, the second of two generation of NIKES to serve at Sandy Hook, are seen being raised to a firing position in this c. 1969 photograph. (Collection Gateway, Sandy Hook.)

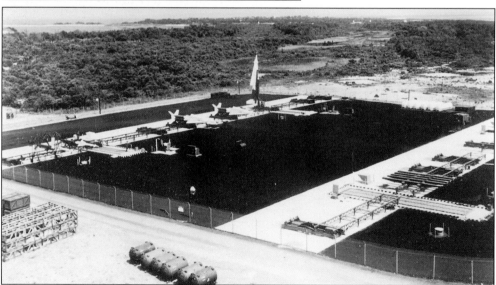

The missile area was about a mile north of the visitors' center, in the vicinity of the South Beach Maintenance Area, which is closed to the public. A NIKE Hercules is in firing position, while an Ajax, an earlier NIKE, is to the far left on its side; two other Hercules missiles are horizontal. On the concrete ramp at right are a launcher, elevator, and conveyor. This 1959 view is one of the few publicity pictures to have been released of the closed operation at Fort Hancock. (Collection Gateway, Sandy Hook.)

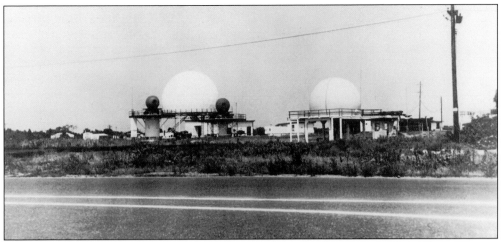

These "golf ball" domes were built *c.* 1955 to protect radar equipment. The early system was replaced with advanced radar in the 1960s. A third NIKE, the Zeus, was planned but not deployed. The platforms are still standing in the vicinity north of Horseshoe Cove, east of the road. NIKEs were made obsolete by the threat of intercontinental and submarine launched ballistic missiles by the time of this 1971 picture. The systems were dismantled in 1974. (Collection Gateway, Sandy Hook.)

Three NIKE missile battalions and the headquarters of the 16th Air Defense Artillery Group were deactivated on August 15, 1974, ending the coastal defense presence on Sandy Hook. Lt. Gen. Leonard Shoemaker, commander of the Army Air Defense Command (ARADCOM), cited as the cause new enemy weapons that made the old defenses obsolete. The ceremonies included casing battalion flags for the last time at Sandy Hook.

Members of Battery F of the 245th Coast Artillery Regiment relax in 1940 at a coffee and doughnut break in a tent city. (Collection Gateway, Sandy Hook.)

Gunnison's 6-inch guns managed to survive the late 1940s disarmament process and were in place when the Smithsonian Institution sought them in the 1960s for preservation. The Smithsonian placed the guns in storage, but later returned them to Sandy Hook, not having found an installation for them. The guns are shown in this February 1976 view as they are being reinstalled at Battery Gunnison, where they remain.

Five

ORGANIZATIONS

Local Sea Scouts, an organization probably drawn from a number of Monmouth County communities, are seen *c.* 1930s in front of one of the Enlisted Mens Barracks. This could be any of the Buildings numbered 22 through 25. (Collection Gateway, Sandy Hook.)

Students are seen on the steps of the Sandy Hook Public School *c.* 1910, when it was a two-story frame structure located just north of the present Coast Guard fence and recreation building parking lot. The building was demolished in the late 1920s or early 1930s. Sandy Hook youths are educated in the Middletown Township system. (Collection Gateway, Sandy Hook.)

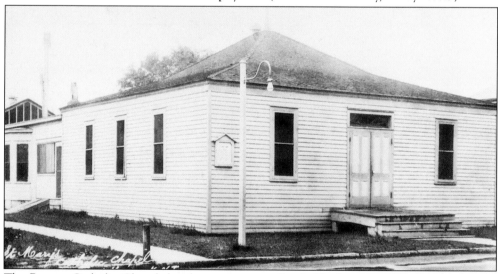

The Roman Catholic Church has been present at Sandy Hook since 1857, but for decades priests served the Hook as an adjunct to other principal assignments. The first priest known to have had this ministry was the Reverend Thomas M. Killeen of Red Bank. The Reverend Robert E. Burke was appointed the first permanent rector in 1898, a time of rising deployment at the new fort. The name St. Mary's was adopted some time in the 19th century. The church building was probably erected early in the 20th century, near the fence now marking the Coast Guard's property. This still-standing chapel was used for worship through World War II. (Collection of Harold Solomon.)

Jiggs, a mascot dog, is peering among the students outside Building 102, the Fort Hancock School. He is standing in front of his owner, Junior Dow, and alongside their teacher, Pearl Murray Masciale. Junior and Jiggs shared a double desk, with the latter awarded a certificate for perfect attendance at the end of an unspecified school year. (Collection Gateway, Sandy Hook.)

The Marine Academy of Science and Technology, popularly known as MAST, opened in 1981 as a four-year high school administered by the Monmouth County Vocational School District. It offers specialized education for marine technology and environmental science to over 250 students. The school is housed in former fort buildings but does extensive work on its 65-foot research vessel, the *Blue Sea*. Reserve Officer Training Corps members have a Friday review on the parade grounds.

A visitor at a fisheries open house is examining a horseshoe crab, a living vestige of prehistoric marine life. The crabs can be found on Sandy Hook beaches.

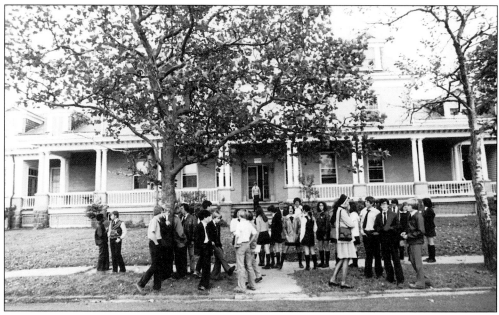

The Sandy Hook Marine Laboratory of the Bureau of Sport Fisheries and Wildlife was located in Sandy Hook in 1961. It was housed inside a converted 50-bed army hospital, Building 19 (see p. 44). They also occupied nearby smaller buildings, which included a number of sea-water tanks. The laboratory has an annual open house; this crowd is gathered for the October 1975 event. The building was destroyed by an incendiary fire in September 1985.

Work on a new marine laboratory began in 1991 and was completed in 1993 as the James J. Howard Marine Sciences Laboratory. This new building was designed by New York architects Beyer Blinder Belle, the same firm that designed a renovation of the lab's premises in the former Barracks Number 74 on the west side of Magruder Road, across the street from this structure. The new building contains a 32,000-gallon, computer-controlled sea-water tank that can simulate ocean conditions.

The Environmental Protection Agency has a presence in Sandy Hook, or at least over it. A helicopter is seen in 1978 taking water samples near the beach. Readers who may recall hearing broadcast water quality reports may be mindful that this is how the process begins. The sampling still occurs twice weekly, near the visitors' center.

The Fort Hancock post chapel, Building 35, was erected in 1941. It was a type of standard-design structure that was built at many military installations. The building, adjacent to Sandy Hook Bay at the north end, survives as an auditorium and is used for a variety of programs. The steeple was removed in 1975 as it "appeared too religious" for a park; its reconstruction has been considered. (Collection of John Rhody.)

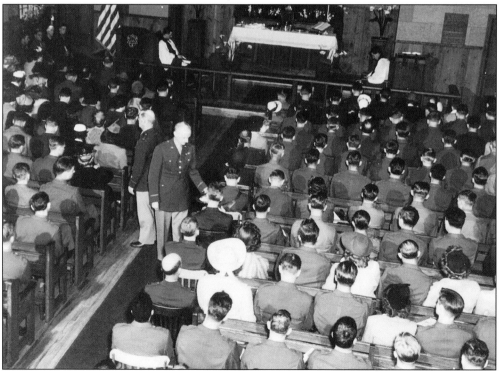

Easter services are shown in this view of the chapel on April 25, 1943. Passing the plate at right is General Gage. One likely gave serious thought to contributing when the commanding officer was making the collection. (Collection Gateway, Sandy Hook.)

Six

RECREATIONAL SANDY HOOK

Sandy Hook is part of the Gateway National Recreation Area, a bi-state park operated by the National Park Service. Other units are at Fort Wadsworth, Great Kills and Miller Field on Staten Island, the Jamaica Bay Wildlife Refuge, Breezy Point in Queens, and Floyd Bennett Field in Brooklyn. The 1,665-acre peninsula includes 7 miles of ocean beaches, salt marshes, hiking trails, and a habitat for migrating shore birds, as well as the historic Fort Hancock area. The June 1974 picture was taken at the start of the NPS's first summer season, prior to the early 1980s installation of fee booths and the removal of the former guardhouse.

Highland Beach was a c. 1890 real estate development in the area around and north of today's highway overpass. It included William Sandlass' pavilion, a bathing and entertainment facility with amusements, dancing, and both ocean and bay beaches. Its name is often associated with the borough of Highlands, but Highland Beach was part of Ocean Township when founded and part of Sea Bright following that borough's annexation of land to its north. The buildings survived to c. 1962; they were demolished when the state park was being developed. This August 1894 photograph was taken by Andrew Coleman.

A state park at Sandy Hook was first proposed in the 1920s and was revived periodically when Fort Hancock's military need waned. In 1962, a state park was opened in the lower section south of the former guardhouse (today's ranger station) and remained in New Jersey's possession until transferred to the federal government following the 1974 closing of Fort Hancock in the northern sector. Traffic jams were common, such as this 1962 example, as Sandy Hook was the state's most frequented park. (Collection Gateway, Sandy Hook.)

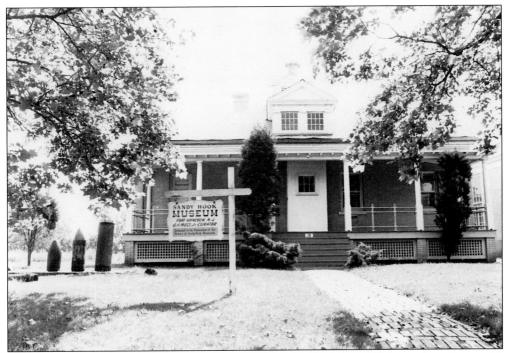

The Sandy Hook Museum was established in 1968. It was co-founded by civilian George H. Moss Jr., a collector and student of New Jersey coast memorabilia, graphic material, and artifacts, and Lt. Col. George Marx. The impetus was the planned discard by the U.S. Army of numerous maps and drawings. Moss suggested the former guardhouse (see p. 33) as the museum site, a building with interior character, thanks to the preservation of its lockup. This photograph dates to 1974; the museum exists today and has changed little.

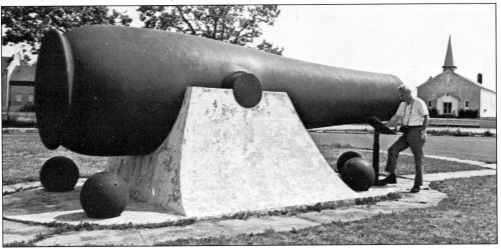

George H. Moss Jr. is seen at the Rodman Gun on a 1970 postcard. He was appointed in 1967 as an historical consultant to the commanding general and, later, as the official historian of the 52nd Coast Artillery Regiment. The museum's mission was the preservation of the history of the Sandy Hook peninsula, with the latter term once in the museum's title. The museum was absorbed by the National Park Service after the army left. The collection that George organized was the beginning of a much-expanded archive that continues to grow.

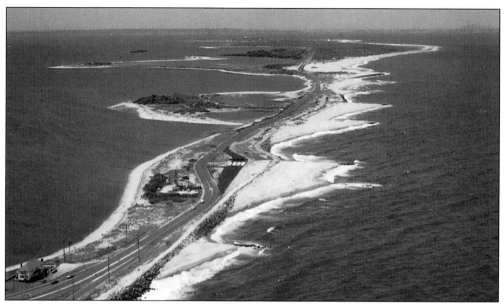

A spring 1983 aerial view looking north shows recently paved access lanes to the new fee booths in the center. The army property line was just below the buildings left of the booths, which was likely also the Middletown Township border. Plum Island, the C-shaped land at left center, was formerly named Island Beach. It was connected to the peninsula in the late 1920s when power lines were erected over it. The house at lower left is the last of the summer cottages that once lined the entire shore south of the base. Sandlass' Pavilion was north of it. The ocean shore has been reconfigured, first by erosion caused by man-made groins and later by sandfill. This postcard is copyrighted by Eastern National Park & Monument Association.

There had been occasional civilian recreational use of Sandy Hook during army occupancy, with security needs governing the regulation against such activity. Bertha Hickey Conover, standing over her friend Rose, recalls rowing to Plum Island from Waterwitch, Highlands, using the tides to make the trip easier. Now retired and living in Colts Neck, Bertie assures readers she had a bathing suit under the hat. She also recalls their presence would at times be noticed by guards, who often warned, "you kids be careful." Note the irregular pile of rocks that made the sea wall c. 1928.

The Sandy Hook peninsula has been an island from time to time (see the inset map on p. 2) and would likely return to that state if not for the considerable and costly exertions of man moving sand. This picture shows Artie Robertson on a bulldozer in 1982. Moving sand is an ongoing process; its extent varies with the toll exacted by seasonal storms.

The state park years saw the marking of trails through the holly and cedar forests. Adventuresome interpreting, created at times from whole cloth, gave the area a past intended to capture the imagination. The author is loathe to repeat these legends in their denial, so imagine the maker and time of this tree marking. Of course, answering a park employee in the 1960s would not be fun.

Clem the Clam and friends are hand puppets designed and constructed by Karen L. Schnitzspahn as teaching aids about the importance of wildlife to Sandy Hook. She is the second from the left in this 1984 view. Patty McGlynn is seen to her right and puppets Poison Ivy, Floyd Fish, Clem the Clam, and Pokey the Turtle, along with Cheryl McDonald and Barbara Lamp (holding Sissy the Seagull) are also shown. Park Service personnel performed puppet shows on the beach, or in the visitors' center on rainy days.

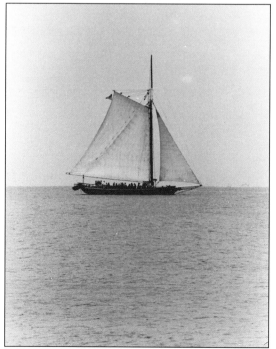

The Clearwater Festival began in the 1970s as a respect-the-environment celebration built around visitor boating trips on the sloop *Clearwater* and music, notably by folk musician Bob Killian. It continues as a major summer festival with the original vessel, much more music, and an amalgam of crafters, merchants, and food vendors that characterize many Sandy Hook events.

Dale B. Engquist was the first area manager of Gateway's Sandy Hook unit. He is pictured with a wind turbine, a well-intentioned if not successful government-sponsored, alternate-energy experiment conducted following the 1970s energy crisis. In this May 1979 view, Howard Hayden (left) and Tom Hoffman are performing roles of surf man and keeper, with a newly received reproduction beach cart at the start of a long run of living history life saving demonstrations. The labor-intensive program was suspended in 1998 for a lack of volunteers.

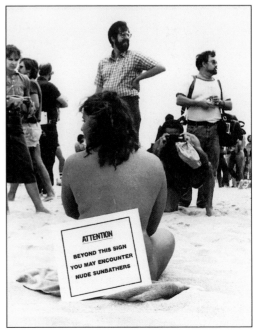

Nude sunbathing is believed to have had a little-known but longer-than-recognized history at Sandy Hook. It was often conducted at an out-of-the-way beach not readily accessible to automobile parking. The activity received much notoriety on July 31, 1982, when members of the Tri-State Metro Naturists redressed the issue by undressing on the beach, attracting a throng of media, gawkers, and other observers. Six were charged with lewdness, a matter that received greater interest in the press than in the courts. Gunnison Beach is now widely recognized as the park's "nude beach," or in sanctioned parlance, a "clothing-optional beach." Ho-hum.

The National Park Service's active collecting and curatorial operation maintains a large collection of photographs, documents, and artifacts relating to Sandy Hook. The collection, founded at the Sandy Hook Museum by George H. Moss Jr. (see p. 121), has grown by donations from many who were stationed or had worked at Sandy Hook and others who recognized the site's special qualities of history, environment, education, and science. Technician Byron Simmons of Louis Berger & Associates is seen in 1997 lowering an artillery shell into an electrolytic bath for preservation.

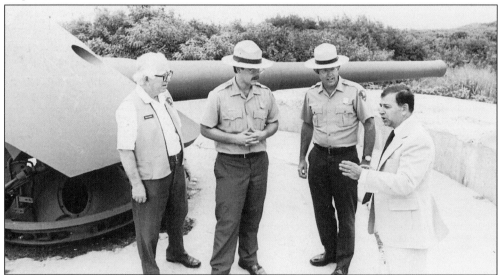

The Sandy Hook Veterans' Historical Society was an active force for a number of years in preserving Sandy Hook history, notably the memories and memorabilia of its members who served there. It was founded by Park Historian Tom Hoffman (second from the left.) Others pictured are shown, from left to right, as follows: John J. Mulhern (see p. 100); Kenneth O. Morgan, unit superintendent; and Sal Giovenco, a World War II veteran and first president of the society. With aging members, the organization disbanded in 1993, lacking a broad base for its perpetuation and absent a mission for embracing all of Sandy Hook's history.

Guardian Park, located at the southern end of the historic area, is a monument to the coastal defenders of Sandy Hook and a memorial to the six army enlisted men and four Ordnance Corps civilian employees who were killed in a May 22, 1958 explosion of eight NIKE missiles nearby in Middletown. The Hercules model at right remains on exhibit at the time of publication, but the Ajax fell in a storm and is in storage awaiting restoration. (NPS photograph by Thomas Hoffman; postcard copyrighted by Eastern National Park & Monument Association.)

A participant in an April 1985 running event passing Battery Potter symbolizes Sandy Hook's change from military to recreational use. Battery Potter is open for occasional seasonal tours and is the first stop on the NPS's "Going Bunkers" tour. The crumbling batteries can be extremely hazardous and warnings are posted against unauthorized visiting.

Sandy Hook's vegetation includes ancient holly and cedar forests and beach cactuses. A great variety of migrating birds can also be found here. Platforms have been erected in the marshes around Horseshoe Cove for attracting fish hawks (ospreys), birds that seek dead trees or the tops of telephone poles for nests—habitats that keep them away from predators, including raccoons and foxes. Yes, when its rains, they get wet.

Four-legged scavengers were an aid to waste control when this goat and a pig were illustrated in the September 1879 *Scribner's Monthly*. The latter's caption was "free lunch." A new ally aids the park now, people. With the 1998 adoption of a "Carry In, Carry Out" policy, visitors are required to remove their own trash. Thus, folks, help starve the raccoon, or at least return him to his "life-in-the-wild" diet.